IMAGES
of America
MORRO BAY

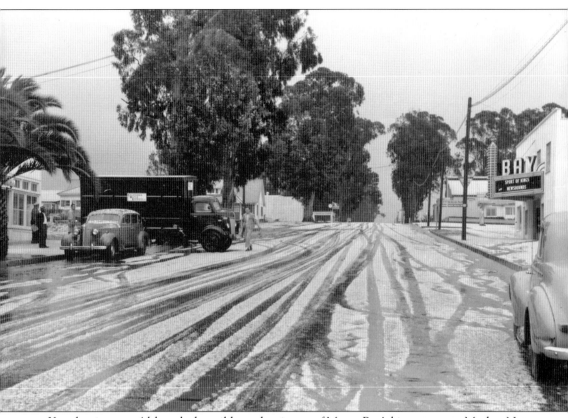

Yes, that is snow. Although the mild weather is one of Morro Bay's biggest assets, Mother Nature can play tricks. Jean Castle took this photograph in the winter of 1949. Note the Bay Theatre marquee and the tall spire that was circled with several multicolored rings of neon flashing up and down, long before disco or laser light shows. The large, black California Motor Express truck, driven by Ephram (Ming) Genardini, brought many of the town's goods from the railhead in San Luis Obispo. (Courtesy San Luis Obispo County Historical Society.)

ON THE COVER: Mention Morro Bay, and anyone who knows of the town immediately visualizes its famous landmark. Morro Rock is certainly one of the most photographed geologic icons in California. This image from an early 1920s postcard (note the evidence of limited quarrying in the lower center) was photographed from the foot of what is today Olive Street. (Courtesy Historical Society of Morro Bay.)

IMAGES of America
MORRO BAY

Roger Castle and Gary Ream for the
Historical Society of Morro Bay

Copyright © 2006 by Roger Castle and Gary Ream for the Historical Society of Morro Bay
ISBN 978-0-7385-3086-4

Published by Arcadia Publishing
Charleston SC, Chicago IL, Portsmouth NH, San Francisco CA

Printed in the United States of America

Library of Congress Catalog Card Number: 2005933423

For all general information contact Arcadia Publishing at:
Telephone 843-853-2070
Fax 843-853-0044
E-mail sales@arcadiapublishing.com
For customer service and orders:
Toll-Free 1-888-313-2665

Visit us on the Internet at www.arcadiapublishing.com

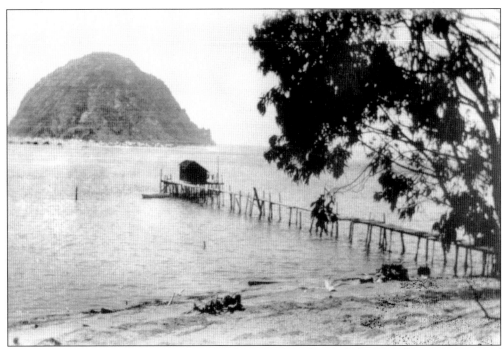

The Church Wharf is pictured here below the end of Sixth Street (now Harbor Street) around 1920. As one of three small wharfs built to accommodate the commercial fishing industry of the time (see Chapter 6), it was constructed by Capt. Clark Church, a bottom fisherman. Note the open north channel. This dock was built far out in the shallow bay to reach water even during the lowest tides. The end, off to the right, still did not reach shore. Instead, a stairway led up from the beach to the wharf. (Courtesy Adele Sylva Costa.)

CONTENTS

Acknowledgments		6
Foreword		7
Preface		8
1.	The People of Morro Bay	9
2.	The Rock	27
3.	The Embarcadero	41
4.	The Back Bay	55
5.	Farming the Valleys	61
6.	Scenes of a Fishing Village	71
7.	The World War II Commitment	89
8.	Snapshots of a Small Town	97
9.	Where People Lived	109
10.	The Things People Did	121
Bibliography		127

ACKNOWLEDGMENTS

First, our thanks go out to the many individuals and groups who located and offered pictures. While we cannot list everyone who helped, credit appears with each image we used. It is gratifying to know that so many wonderful treasures are being preserved by our caring members and friends.

Any historian is deeply indebted to those who have gone before. Our appreciation goes to Jane Bailey for her kind assistance and to the magnificent way that she has preserved her lifetime of research.

The largest collection of Morro Bay and maritime photographs were taken and processed by Glen Bickford between 1935 and 1990. A big thank you goes to his brother, Wayne, for his help on this book and for the many hours spent working to preserve and catalog this magnificent legacy. Glen was very generous with his photographs, which appear in many collections throughout the area. Credit is given where recognized and/or documented.

Many have shared their memories of these images and the history they represent. We would particularly like to thank Wayne and Norma Bickford, Adele Costa, Jean Leage, and Pat Nagano.

This project could not have been completed without the tireless efforts of our computer wizard, Janice House. Janice scanned most of the images included here and has spent countless hours preserving many of the collections represented.

Thanks also to Nancy Castle and AGP Video for office space and the use of computers, copiers, and phones.

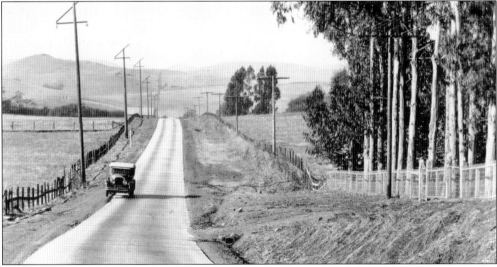

The first automobile road to Morro Bay was cement and completed in 1923. It wound out from San Luis Obispo, through the farms of the Chorro valley. This shot was taken near what is today the north entrance to Cuesta Community College. It was an hour's journey into San Luis Obispo in those days. It remained so until well into the 1950s, although part of the road was widened to four lanes during World War II. The remainder of the "freeway" to Morro Bay was completed around 1960. (Courtesy Juanita Tolle.)

Foreword

Morro Bay, along California's central coast, is among the most visually spectacular communities in America. It has a rich early history that stretches back to the adventures of the Chumash and Salinan Native Americans, with visits by Juan Rodriguez Cabrillo and the Manila Galleons of the 16th century.

The area's modern history begins with the tragic story of one of the town's founding fathers, Rev. Alden B. Spooner. During the midst of a heavy arctic storm on the night of February 5, 1877, Reverend Spooner heard the call of duty as the steamboat *Mary Taylor* was overdue. The reverend wasn't feeling well, but he rowed out into the squall in his small boat. In the north channel near Pilot Rock, his craft capsized. His body was never found.

Prohibition stories about the Rock abound, as economically hard-pressed farmers, fishermen, and tugboat operators facilitated the landing of Canadian whiskey and other distillates near Morro Bay. In the 1930s, an eclectic group formed a literary society to bring high culture to Morro Bay. It included Miles Castle and other refugees from a failed land settlement for English immigrants in the Central Valley; Neil Moses, a colorful newspaper editor; Dorothy Gates, a college librarian; and Dr. Jack Levitt, a physician from Minnesota.

In the beginning, Morro Bay's history was passed on from family to family during the evenings in the then remote fishing village. Much of this oral tradition was later gathered together by Dorothy Gates, Jane Horton Bailey, and others and preserved in print. As the community grew conscious of its rich past, preservation groups were formed. They continue today, gathering both artifacts and images to preserve Morro Bay's history.

This book is a wonderful product of that effort, with dozens of long-forgotten photographs depicting the way things were. The energy and enthusiasm put into this project are evident. It is a model for other communities, demonstrating a methodology for making history come alive.

—Dan Krieger
Professor of History, Emeritus
California Polytechnic State University
San Luis Obispo, California

Professor Krieger is the author of Times Past, *a weekly feature of the* San Luis Obispo County Tribune *since 1984, and of regional histories dealing with San Luis Obispo County.*

Preface

A friend of ours completed her college education late in life. At first, the younger students treated her with polite deference, albeit with raised eyebrows. Then the stories began, stories of a childhood in a country united in war. Stories of scrap drives, ration books, and a fear of telegrams. As the semester progressed, many of the students began to look forward to the class discussions. They heard many accounts of a country in and out of wars, of good and bad times, of successes and disasters.

There was one particularly memorable discussion about a slain president, the shock of the news, and the silence that descended on cities large and small that afternoon. As they were reluctantly leaving the lecture hall, a stressed young collegian asked the lady, "How do you keep all this stuff straight? I've studied all night and I still get confused. After all, it's just history."

"Ah," said the lady, "it may be just history to you, but it's memories to me!"

We present here memories in various stages of becoming history. That, after all, is one reason for historical study—capturing the memories. We have chosen many of these images for their ability to elicit such memories. We hope each page will spark some in you, maybe of good times in Morro Bay, or maybe of good times in your hometown. Enjoy them. Share them with friends and family. And share the resulting new memories with us, please.

—The Historical Society of Morro Bay
Roger Castle
Gary Ream
PO Box 921
Morro Bay, California 93443

One
THE PEOPLE OF MORRO BAY

Franklin Riley is considered to be the true founder of the city of Morro Bay. An enterprising farmer, businessman, and politician, Riley had been in the area since the 1860s. He recognized the potential of the locale and knew that it lay outside the Mexican land grants. He secured a homestead from the government in what would become the center of town. In 1872, he and his friend Carolan Mathers, who was a surveyor, conceived the layout of the streets of Morro Bay. A reproduction of Mathers's map is found on page 98. (Courtesy Historical Society of Morro Bay.)

 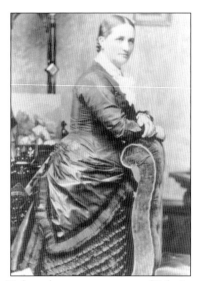

Pictured are William H. Halstead (left) and his wife, Emma. Halstead, a contemporary of Riley's, established a farm about five miles east of town, along the wide, fertile Morro Creek valley. Some of his neighbors were William Langlois, Mathias Gilbert, John Greening, and James Tanner. These pioneers and their children would help build and populate the future town of Morro Bay. (Courtesy Historical Society of Morro Bay.)

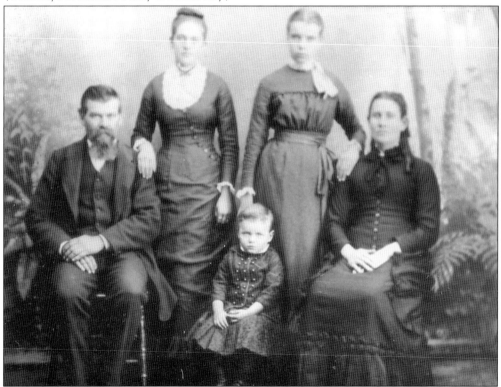

This early photograph of the Halsteads includes their daughters Emma and Ida and their son Charles. Ida later married a Mr. Fennemore, and Emma married David Spooner, of another pioneer family. The sisters later worked at the Spooners' store. (Courtesy Historical Society of Morro Bay.)

Annie Schneider was the youngest child of Mathias Schneider. Born in 1887 while the family was living near Baywood Park, Annie lived mostly in Morro Bay until her death in 1981. The family lived in a large Victorian house (see page 111) in the center of town and operated some of the first stores as well as a boardinghouse. Annie is pictured here in her nursing uniform sometime after 1914. (Courtesy Jane Bailey.)

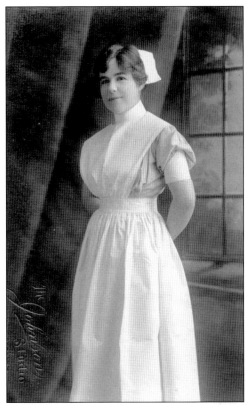

Annie was often seen around town in this buggy. This undated photograph has "Annie Schneider Woods and her buggy" handwritten on the back. The other woman is unidentified. This location seems to be the broad beach just north of the Rock. Note the blinders on the horse. (Courtesy Historical Society of Morro Bay.)

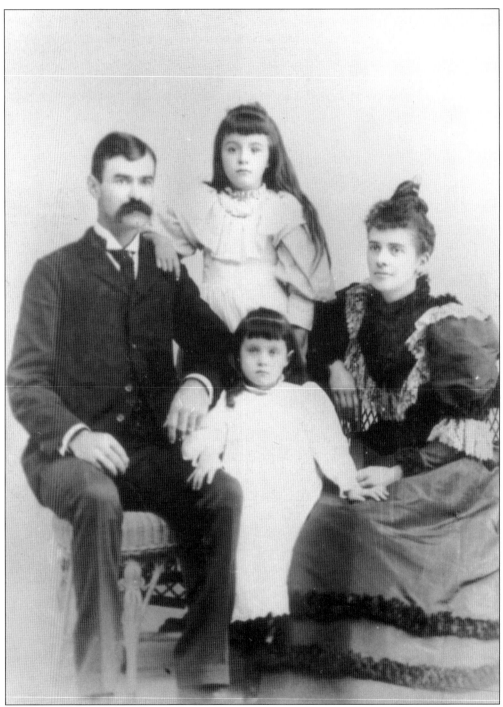

Pictured here are Mr. and Mrs. David R. Spooner and their daughters Emma Nadien (front) and Ida Roxanna (back). David and his five brothers and sisters grew up on a farm on Toro Creek. Their father was the Reverend Alden B. Spooner, mentioned in this book's introduction. David married a neighbor's daughter, Emma Halstead, and they built their home in the new town of Morro Bay (see page 111). (Courtesy Historical Society of Morro Bay.)

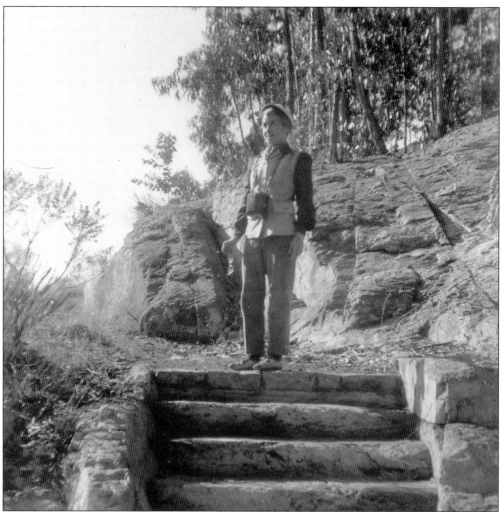

Emma Nadien Spooner is pictured here around 1957. In her adult life, she was known as Nadien Richards. Born in 1905, she died in 1999 and spent most of her life in Morro Bay. She was active in many cultural areas and was married twice. She is seen here on the stone steps (a Works Progress Administration project during the Depression) just south of the natural history museum. (Courtesy Roger Castle.)

Like many of Morro Bay's early residents, Ivar Holdt was an immigrant. He was sent to the United States at the age of 12 from his native Denmark, presumably to escape the political conditions there at the time. He came to Morro Bay as a young man and served as town constable for several years. He died in 1930. (Courtesy Adele Sylva Costa and Janice Cooper.)

Primary Election Aug. 31, 1926

IVER M. HOLDT
CANDIDATE
FOR CONSTABLE
Morro Judicial Township

The patriarch of the Sylva family was Cornelius Sylva, who came to Morro Bay around 1917 from California's Central Valley near Castroville. He was married to Clara Mesquit, who died giving birth to her third child. Sylva and his son Alfred were among the first commercial fishermen in Morro Bay (see page 80). (Courtesy Adele Sylva Costa.)

This is Cornelius's sister Lena (Sylva) Chesea. Note the three little houses up on the bluff. The family leased the one on the right for their home as well as the wharf below. The shed behind Lena was for drying nets. (Courtesy Adele Sylva Costa.)

Pictured are Cornelius's daughter-in-law Lillian Ethel (Holt) Sylva and her daughters Velma and Gwen. Lillian and her husband, Alfred, had five girls and one boy, Alfred Jr. (Courtesy Adele Sylva Costa.)

Grandpa Cornelius Sylva and his grandson Alfred Sylva Jr. are pictured at the bay near the Sylvas' wharf. Note the Ship restaurant behind him and the saltwater plunge behind it (see page 42). The presence of the Ship dates the picture to the early 1920s. (Courtesy Adele Sylva Costa.)

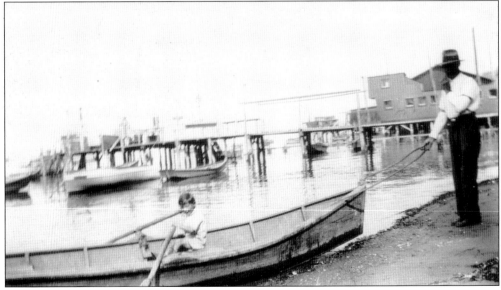

The Sylva girls stayed in the area, Velma marrying Charles Barrio and Gwen marrying abalone diver Charlie Pierce. They are pictured here on the bluff above the wharf. (Courtesy Adele Sylva Costa.)

Here Velma and Gwen are pictured again a few years later. With them are grandfather Cornelius and brother Alfred Jr. The Sylvas were typical of the families that have always made Morro Bay a strong community. Hardworking and resourceful, they made good use of what the area and the times offered. (Courtesy Adele Sylva Costa.)

The Naganos are another well-known family that helped make Morro Bay what it is today. Yoshio (George) Nagano came to California from Japan in 1913. After working with his brothers for a time, he and his wife Kanaru began farming near Morro Creek, northeast of town, around 1917. They had five children, and Yoshio is pictured here in one of his seed flower fields with his eldest sons, Bill and Pat. (Courtesy Pat Nagano.)

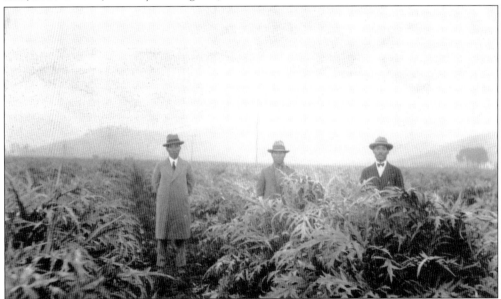

The Naganos had one of the most successful farming operations in Morro Bay. Among the many firsts that George gave to the area was the cultivation of artichokes. They grew well in the flat bottom land bordering Morro Creek. George is pictured here (center) with his brother Take Eto (left) and an unidentified friend. George and two of his brothers were adopted by the childless Nagano family to preserve the family name, a common Japanese custom at the time (see Chapter 5). (Courtesy Pat Nagano.)

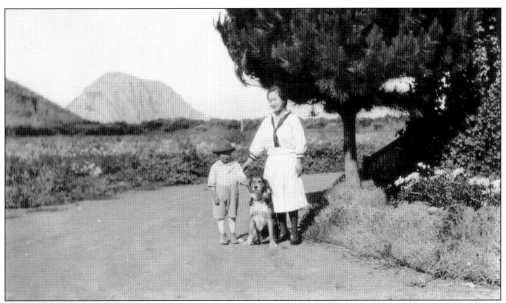

George's second-eldest son, Pat, is pictured here with his aunt on the family farm. Pat and his four brothers and sisters were born and raised in Morro Bay. During World War II, the federal government interred many Japanese-Americans in relocation camps. Pat enrolled in the army and spent most of the war as a translator in the eastern United States and Europe. Most of his family, however, was forced to relocate. After the war, they returned to find their farm and home intact due to the kindness of neighbors. Pat resumed farming in Morro Bay and served many years on the local school board. (Courtesy Pat Nagano.)

Pat's oldest sister, Ellen, and an older friend pose on one of the farm horses around 1925. Note the field of sweet peas, one of the family's first crops. (Courtesy Pat Nagano.)

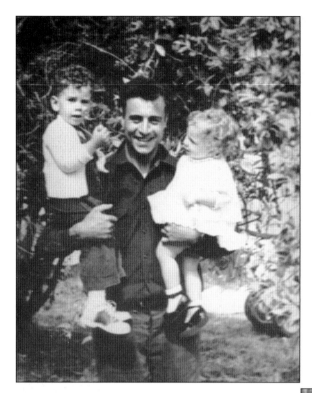

This is Joseph Giannini Sr., holding Joseph Jr. (known as Jody) and his sister, Elaine in a c. 1948 picture. Joseph Sr. was the founder of Giannini's Marine Service and Equipment store on Market Street. Jody began working in the store as a child and eventually took over the operation from Joe Sr. and ran it until his death in 2005. (Courtesy Elaine Giannini.)

One of the supporting players in the development of Morro Bay was Russell Noyes and his wife, Edith. Russell is pictured in this photograph as the first chief ranger of the new Morro Bay State Park. His wife was a well-known real estate agent. In addition to his duties as chief ranger, Russell was also one of the managers of the golf course. He and his wife lived for a time in the original clubhouse located on White's Point near where the natural history museum is today. Pictures of the clubhouse and the golf course appear in Chapter 10. (Courtesy San Luis Obispo County Historical Society.)

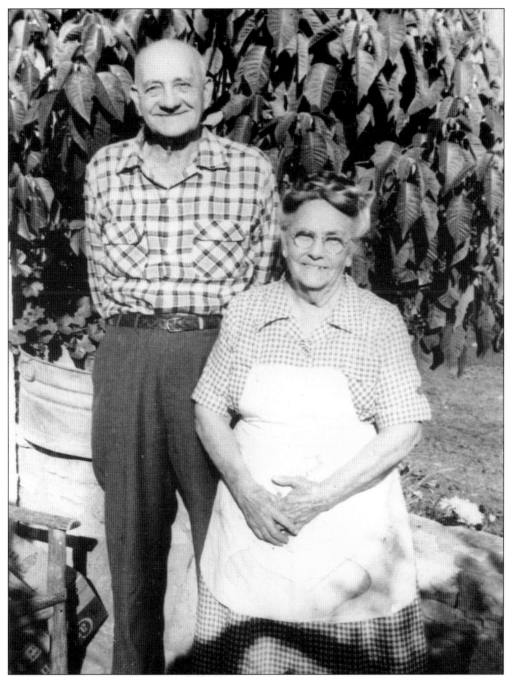

According to Jane Bailey, Paul and Mary Whitlock were among the first to recognize the tourist potential of Morro Bay. In the late 1920s, they purchased land at the mouth of Morro Creek west of Highway 1. There they built a home for their family of four children and also cleared land for a campground. They grew vegetables in the fertile soil, and Mary, a registered nurse, set up a first-aid station in their home. During the Depression years, the family helped many people, visitors, and locals alike, and were always willing to provide what assistance they could. (Courtesy San Luis Obispo County Historical Society.)

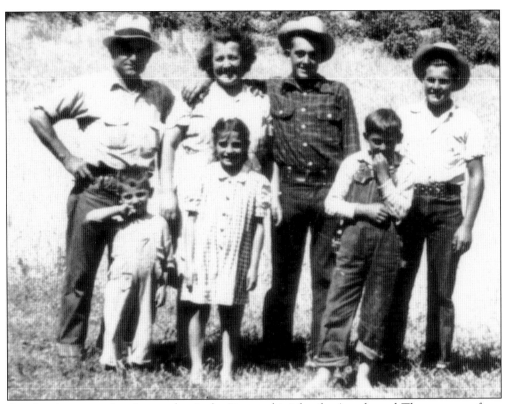

Another important immigrant clan is the Domenghini family. Angelo and Theresa came from Switzerland in the early 1920s. By 1930 they had established a dairy at the eastern entrance to Morro Bay. In the above image, Louis is to the right of his mother and Americo is on the far left in the back row. In the front row are Dario, Doris, and Roy. The four boys took over the family operation after Angelo's death in 1958. The below left photograph shows Eduardo Bettrametti, a relative, around 1967 by the dairy entrance. Below right are Angelo and Theresa, c. 1940. (Courtesy Betty Domenghini.)

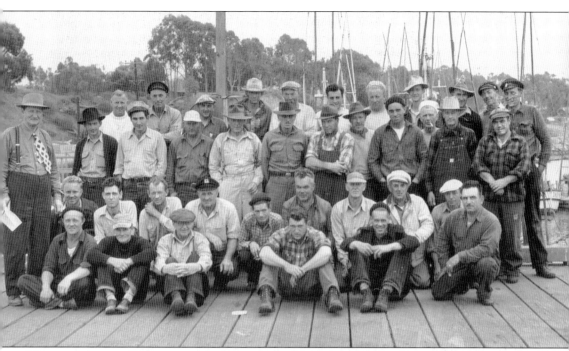

This motley crew of fishermen and others is gathered on the south pier for an unknown reason. Although mostly unidentified, the picture is from the mid-1930s. The man to the left with the loud tie on is real estate broker Milt Rohrberg. In the fourth row, second from the right, is Harold Elmore; the blond man, fifth from the right, is Larry Casper; and next to him is Joe Giannini Sr. In the second row, second from the right with the white cap, is Bill Casper. (Courtesy Al Jorge.)

Several images of Hugh Pomeroy (pictured at right) were found in Bill Roy's collection of early real estate photographs. Pomeroy was associated with T. J. Lawrence and his Morro Vista development. He was a pioneer in urban planning, born in Burbank, California, and educated at Occidental College in Los Angeles. Beginning in 1923, he served one term as a California assemblyman. He was also director of the Los Angeles County Regional Planning Commission, where he wrote one of the first county zoning ordinances in the country. Pomeroy later moved east and served as a city planner in Virginia and New York City. (Courtesy Juanita Tolle.)

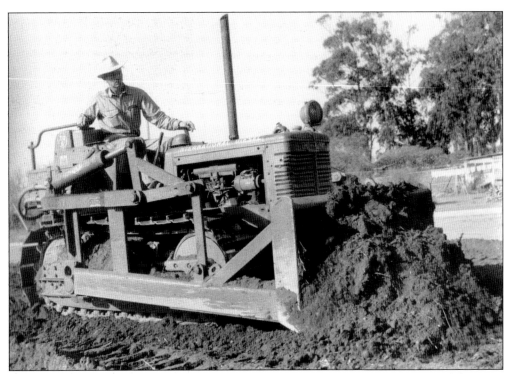

Many contractors and workmen contributed their skills in building Morro Bay. One of these was C. D. Sissel, a handy man with a truck and tractor. According to Wayne Bickford, who began his own cement-contracting business working for him, C. D. and his father began by shoveling rock and sand from the beach by hand in the 1940s. They would mix the cement in a small "half-sack" mixer and pour the foundations for many of the homes in town. By 1956, when Glen Bickford took these photographs, C. D. was the man to see if dirt needed to be moved. The top picture shows him grading the lot for Kay and Tommy Thomas to build the Chat and Chew restaurant on the corner of Harbor and Main (see page 26). (Courtesy Wayne Bickford.)

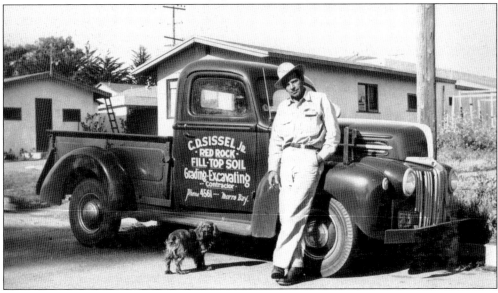

Glen Bickford took many of the photographs that appear in this book. Glen came to Morro Bay in 1935, working as an abalone diver and fisherman (see Chapter 6). He took hundreds of vibrant, well-composed photographs. He recorded his work in the maritime industries, the towns he lived in, and the people he knew throughout the West Coast. Thanks to the efforts of his brother, Wayne, these photographs have been well preserved. Glenn is shown here holding a red abalone with large barnacles. (Courtesy Wayne Bickford.)

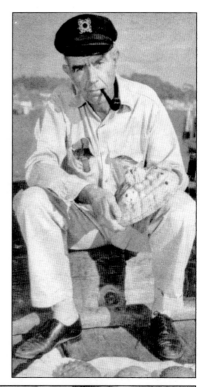

The Bickford family came to Morro Bay from Iowa. This July 20, 1952, photograph shows brothers and sisters Glen, Clara, Wayne, and Mable. (Courtesy Wayne Bickford.)

Around 1951, Lavern and "Loggie" Loggins reopened the Thomas's closed Chat and Chew restaurant, across Main Street from Happy Jacks. The town was endlessly amused when the new sign went up that read "Chat 'N Chew Terrible Food." Friend of the Thomases and longtime Morro resident, Norma Bickford takes credit for the first part of the name "because we used to gather [in the old Cozy Nook] to chat and chew, but the last part is all Tommy!" (Courtesy Wayne Bickford.)

Miles Castle was another of Morro Bay's British immigrants. Trained as a farmer in his native England, Miles came to Morro Bay after a Porterville, California, orange farm project failed. Like many other expatriate Brits, he found the area much like home. Miles built an adobe house here during the Depression (see page 109). Miles began the first garbage collection service and opened the first nursery in town. Here he is seen in his hand-weaving shop on Fifth Street, now Morro Bay Boulevard. Miles began weaving, a life-long dream, after his new mother-in-law bought him his first loom in 1932. He made the cloth for the "dirndl" skirts and the handbag shown by the unidentified models. (Courtesy Nancy Castle.)

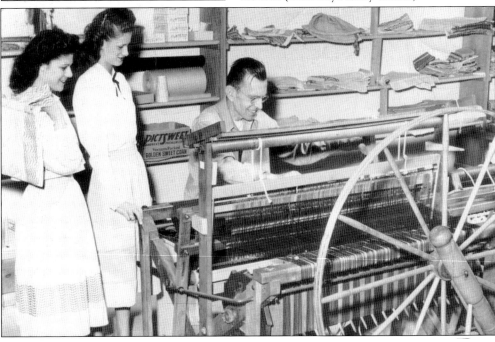

Two

THE ROCK

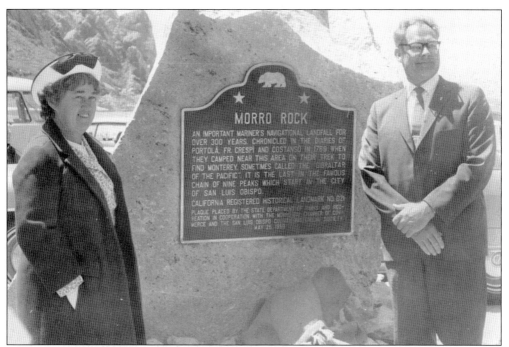

Morro Bay and Morro Rock are synonymous in the minds of many, visitors and locals alike. The rock is arguably one of the most photographed geologic structures on earth, and this chapter presents several views of the internationally famous landmark. The Rock was declared a State Historic Landmark in 1968 and was closed to public climbing to protect nesting peregrine falcons. The county historical society and the Audubon Society erected this plaque in 1988. Pictured at the plaque's dedication are Patricia and Loren Nicholson. (Courtesy San Luis Obispo County Historical Society.)

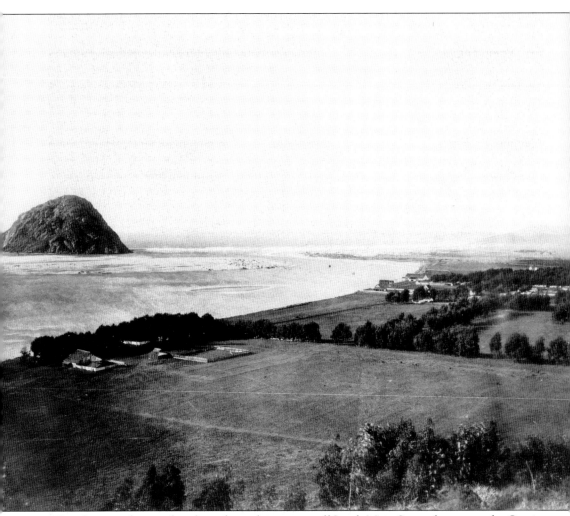

This photograph was taken from the rocky rise just off South Main Street, known as the Cerrito or Eagle Rock sometime before 1889; note the open channel north of the rock. That is the J. C. Stocking ranch (see page 110) on the left. At the right, up on the bluff above the harbor, there can be seen several warehouses and other businesses. The large white building is the grain warehouse. The slip or wooden trough used to slide grain sacks down to the wharf and directly into the schooner's hold can also be seen. J. C. Stocking had his welding shop just in front of that warehouse. (Courtesy Historical Society of Morro Bay.)

This view of the rock is from the west end of Fifth Street (now Morro Bay Boulevard). In 1925, this was the home and office of Kate and A. Manford Brown, a prominent realtor. Later it would be the site of the original Breakers Café, now Dorn's. Historian Vic Hanson attributes this photograph to Lillie Brown Anderson. (Courtesy Juanita Tolle.)

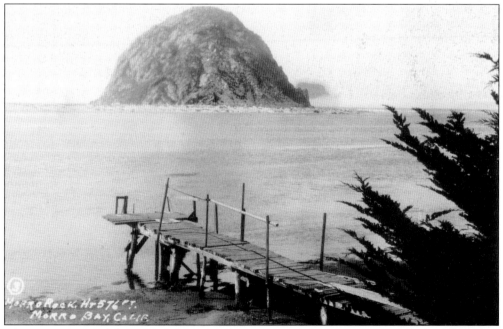

This 1920s postcard shows the rock from above what is believed to be the Riley and Williams Pier. Note that the center of the Rock is unaffected by blasting or quarrying, further dating this photograph to before 1936. (Courtesy Historical Society of Morro Bay.)

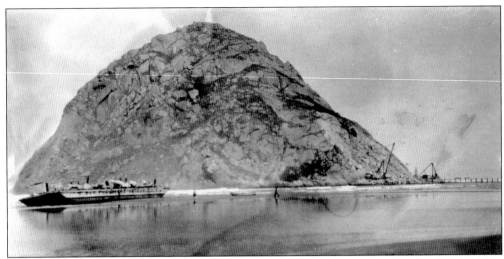

Such a large pile of rock, sitting right there on the edge of the ocean, naturally drew builders in search of stone. Many early home foundations and fireplaces were made from loose rock "found" there after more official quarrying operations. As early as 1890, stone was blasted from the sides of the Rock and used for breakwaters at Avila Harbor. (Courtesy Historical Society of Morro Bay.)

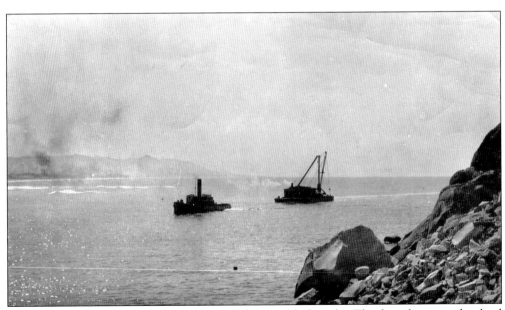

The tugboat *Liberty* is seen here positioning a barge with derricks. The derrick was used to load the blasted rock onto another barge for the trip south to Avila. (Courtesy Historical Society of Morro Bay.)

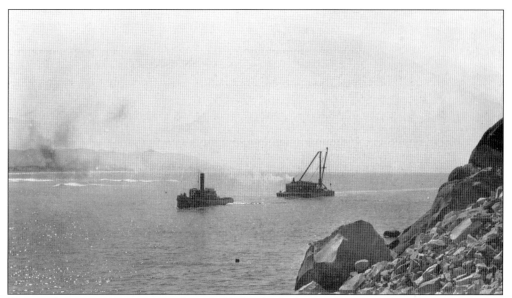

From earliest times, sea captains have held that both the north and south entrances to Morro harbor were dangerous. The effort to mine material here was a major undertaking. The tugboats and barges had to contend with waves coming from both sides of the Rock, as seen here. (Courtesy Historical Society of Morro Bay.)

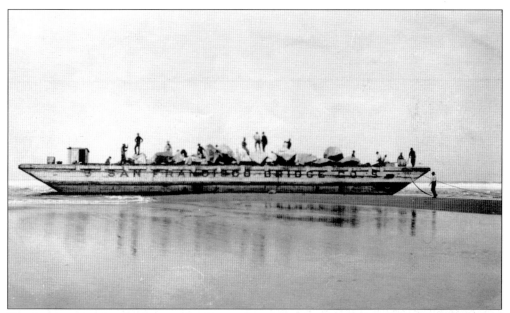

The dangerous work sometimes resulted in accidents. At one point a hawser from the tug broke and the loaded barge drifted onto the beach as seen here. According to historian Jane Bailey, in 1910 the San Francisco Bridge Company received permission from the government to build a trestle connecting the rock with the shore. One night a loaded barge capsized and dumped its contents into the north channel. This improved conditions in the harbor dramatically and the contractor was allowed to add more rubble to the area. This began the closure of the north entrance to the bay that was completed by the WPA in 1935. (Courtesy Historical Society of Morro Bay.)

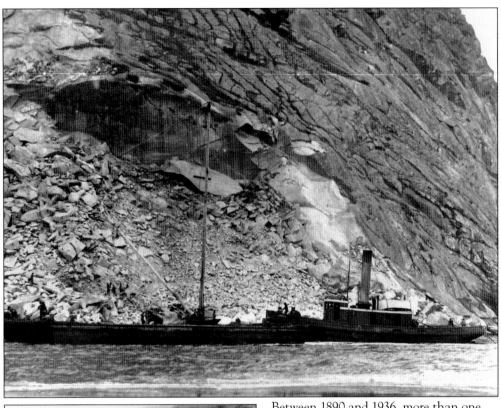

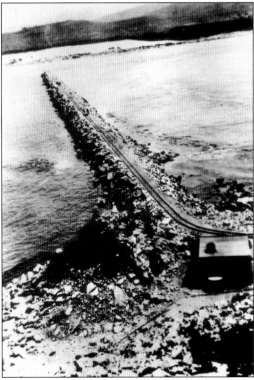

Between 1890 and 1936, more than one million tons of rock were taken for various projects. In 1936, the breakwater and south jetty were first built. A comparison of early and later pictures in this chapter show the changes these activities brought about. By 1963, a moratorium on any further quarrying was declared and in 1968 the Rock became a State Historical Landmark. (Courtesy Historical Society of Morro Bay.)

Rubble from the various quarrying operations was used on the 1935 WPA project and resulted in a narrow, rocky closure of the north passage. Due to the advent of World War II, the causeway stayed much as it was built well into the 1950s. Later tailings from dredging of the bay filled it out to its present width. When Pacific Gas and Electric (PG&E) built the power plant in 1953, a cooling water outfall line was constructed under this area. (Courtesy Historical Society of Morro Bay.)

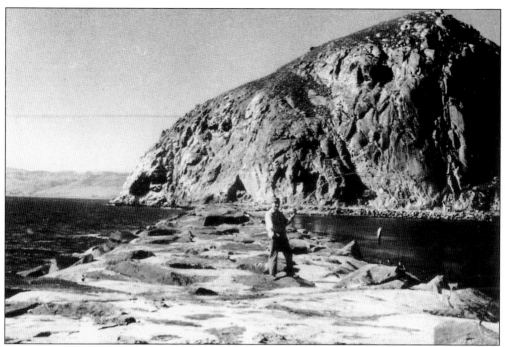

This is the northern breakwater in 1951. Storms in 1955 and 1956 caused significant damage, and more stone was taken from the Rock for repairs. Fishermen, like Joseph Gerber pictured here, and sightseers are now discouraged from venturing into the area. Even on calm days like this, occasional waves breech the barrier. (Courtesy John Gerber.)

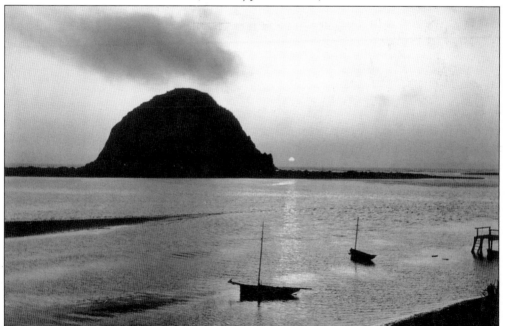

The Rock is subject of countless artistic photographs and paintings. This one was probably taken in the late 1930s judging by the closed north channel and the silted condition of the harbor. (Courtesy Juanita Tolle.)

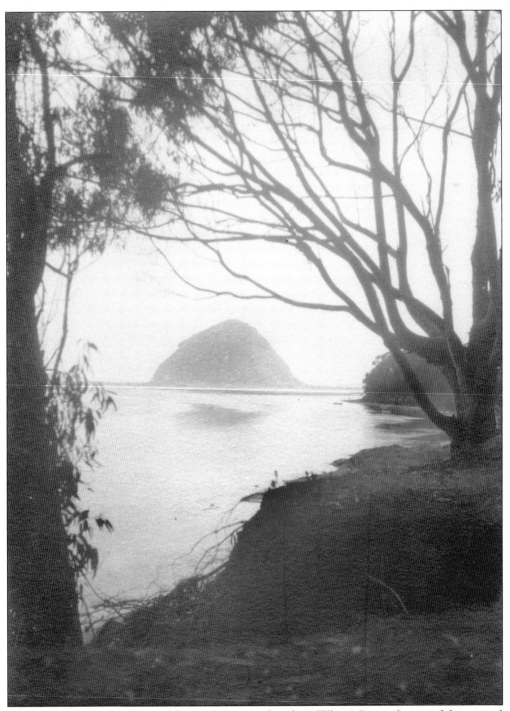
Here is another lovely picture of the Rock. It was taken from White's Point, the site of the natural history museum. The date of this photograph is unknown, but it was most likely taken before the museum was built in 1961. (Courtesy Frances E. Goodrich.)

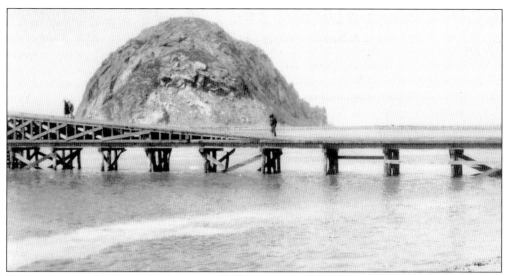

Yes, at one time there was a bridge across the bay. It was built by the military to facilitate training exercises on the sand spit. The public was allowed to use it through the war years. After the navy base closed and commercial activity began on the new embarcadero, the bridge was dismantled to allow larger vessels into the back harbor. (Courtesy Roy Klein.)

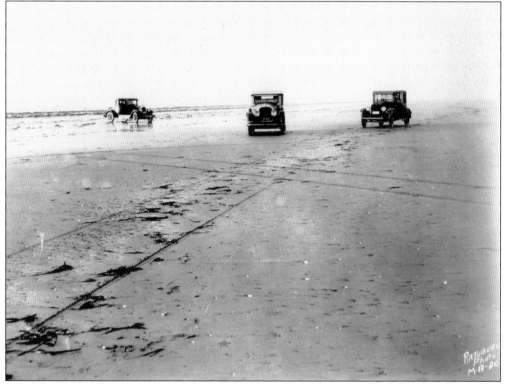

With the advent of the automobile, driving on the beach became a popular pastime. This picture of late 1920s cars is from the collection of William "Bill" Roy, who was active in real estate and the creation of the golf course. The images were used in the advertising of the Miller and Murphy residential developments (see Chapter 8). (Courtesy Juanita Tolle.)

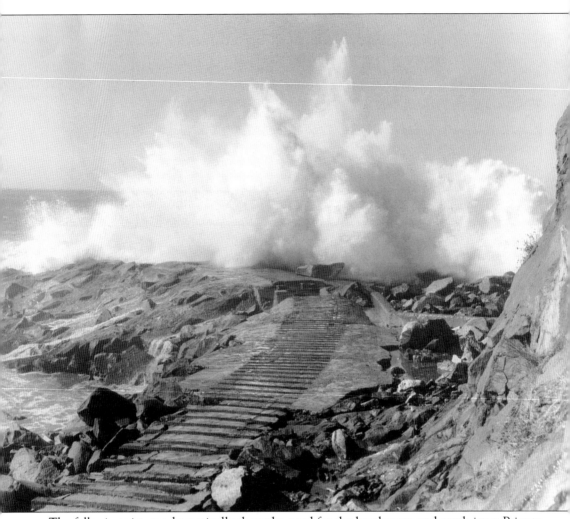

The following pictures dramatically show the need for the breakwater and south jetty. Prior to the 1936 entrance to the harbor, either north or south of the Rock was more treacherous than today. Storms like these would periodically close the north channel, silt up the harbor, or break through the sand spit. Locals and visitors alike are drawn to the area to watch shows like this in the 1950s. (Courtesy Wayne Bickford.)

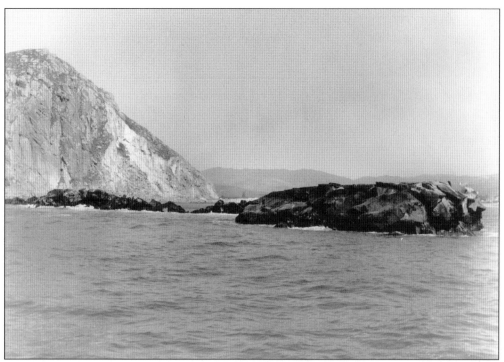
Storm-driven ocean waves are one of nature's most powerful forces. Storms at sea can cause heavy waves that hit the breakwater dramatically. This photograph was taken from outside the harbor after a particularly large storm in 1954. (Courtesy Wayne Bickford.)

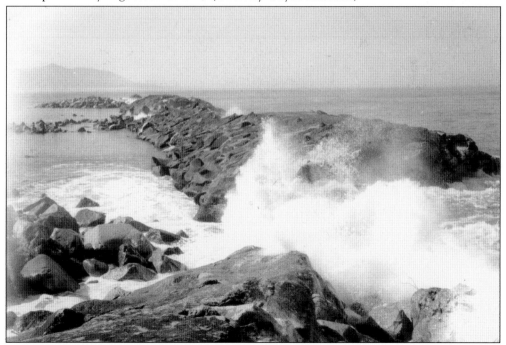
The power of these waves displaced tons of rock off the breakwater. Note how a whole section of rock at the tip of the breakwater has been moved eastward several feet. (Courtesy Juanita Tolle.)

The harbor has seen many stormy winters. This 1981 or 1982 shot of the parking area on the south side of the Rock illustrates the lure of nature's displays. The sightseers are in no

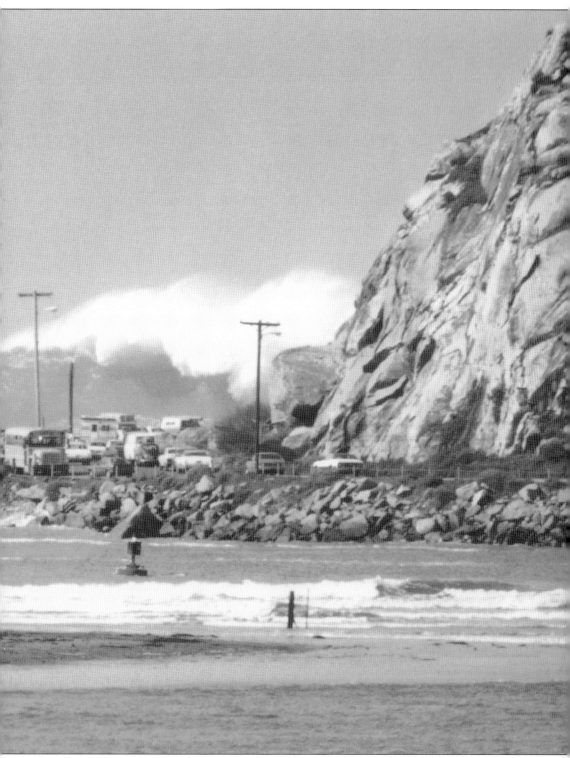
immediate danger, although the telephoto lens distortion makes it appear so. (Courtesy Morro Bay Harbor Department.)

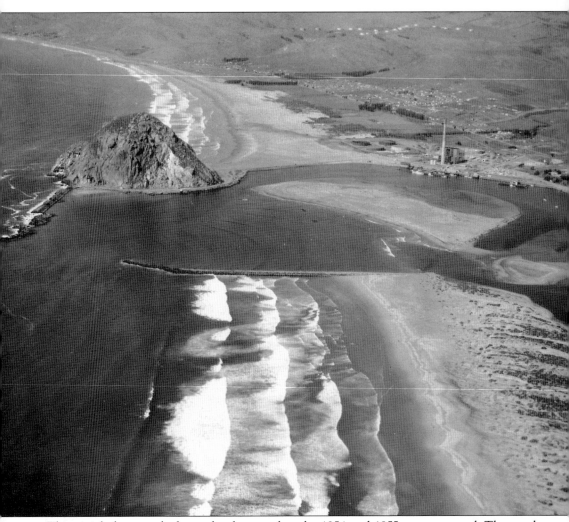

This aerial photograph shows the damage that the 1954 and 1955 storms caused. The north breakwater displacement can be clearly seen. The sand spit was cut through to the harbor at the south jetty. Note also the PG&E plant, with only one stack, under construction. (Courtesy Juanita Tolle.)

Three

THE EMBARCADERO

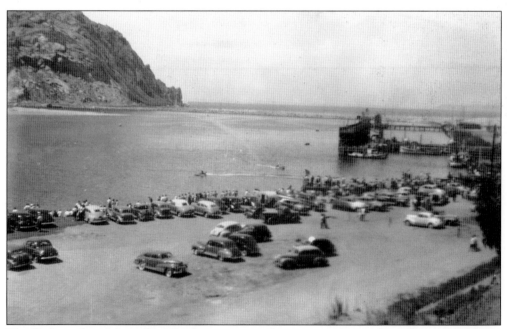

The Embarcadero, Morro Bay's harbor commercial area, was a legacy from the navy presence during World War II. The navy also built the north and south "T" piers for training and logistic purposes (see Chapter 7). After the navy left town, the two-story training scaffolding remained on the south pier as this 1945 or 1946 postcard shows. (See page 45 for another view.) (Courtesy Historical Society of Morro Bay.)

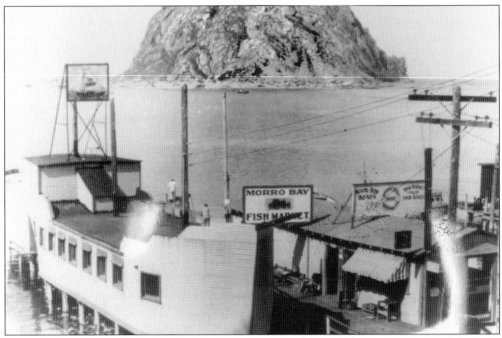

Before there was an embarcadero, there were still several bayside businesses. One of the most unique was this boat restaurant, the Ship Café. It was built around 1927 and meant to resemble explorer Christopher Columbus's *Santa Maria*. The café was managed by Basil and Henrietta Jackson, two more British immigrants living in Morro Bay. The Jackson's also operated the fish market next door and lived in part of the "ship." J. C. Stocking and his sons built the wharf in the 1870s. The site is at the foot of the present Morro Bay Boulevard, about where the giant chessboard is now. (Courtesy Wayne Bickford.)

One of the earliest to act upon the commercial potential of Morro Bay was Alfred Sylva (today spelled Silva) and his father Cornelius (see page 15). Shortly after 1900, they leased the first of the three small houses seen here. They were up on the bluff at the foot of Fifth Street, now Morro Bay Boulevard. The rough road behind the homes was one of the few down to the bay at the time according to Al's daughter, Adele Costa. The wooden objects in the foreground are small flat-bottom boats stored upside down. (Courtesy Adele Sylva Costa.)

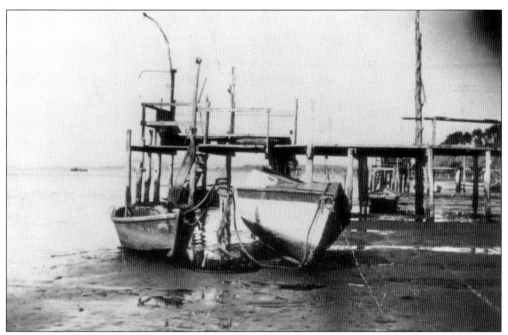

The family also leased the small wharf below their home. Al erected a small shed at the shore end of the dock used for net storage, which also served as a fish market. In addition to fishing, the Sylvas also were guides for the many duck and geese hunters who came to the area. Cornelius fished by net from a small boat in the bay; note how shallow the bay was at the time. At low tide the small boats were almost entirely out of the water. (Courtesy Adele Sylva Costa.)

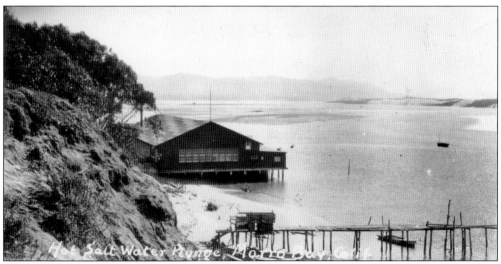

The largest natural part of the embarcadero was just to the north of Sylva's wharf, between Morro Bay Boulevard and Harbor Street. On this land a large wooden building was constructed to house an indoor salt-water plunge. Due to financial problems it only operated for a couple of years. However, the building's sheer size and location make it an important landmark for this era of the waterfront. This picture was taken from the bluff near Beach Street. (Courtesy Juanita Tolle.)

This picture shows just one corner of the saltwater plunge building and its parking lot. The Morro Bay Fish Market was operated by the Jacksons, who also managed the Ship Café, which is out of the picture to the left. (Courtesy Historical Society of Morro Bay.)

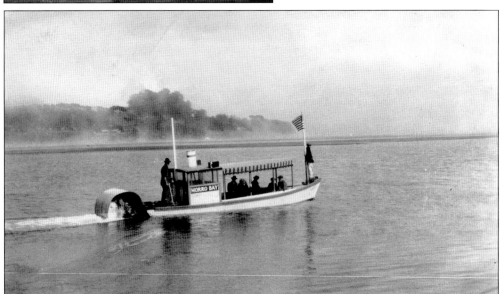

Here is another water taxi with an unusual rear paddle wheel used for propulsion. The photograph is part of Elizabeth and Bill Roy's collection from the mid-1920s. The taxi was likely financed by the real estate interests in town as a means of showing the bay to prospective buyers. (Courtesy Juanita Tolle.)

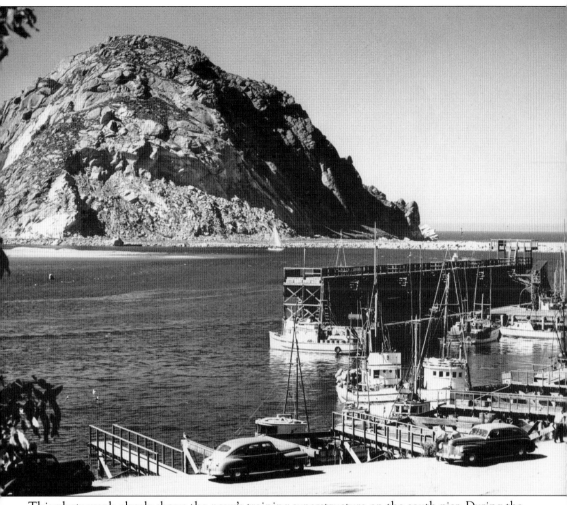

This photograph clearly shows the navy's training superstructure on the south pier. During the war years the navy would not allow the public the use of the pier and the pedestrian bridge (see page 35) only allowed small boats into the back bay. These factors, and the war itself, restricted the commercial growth of the waterfront to a minimum. However, by 1950, approximately 40 commercial and party boats called Morro Bay their home port. (Courtesy Juanita Tolle.)

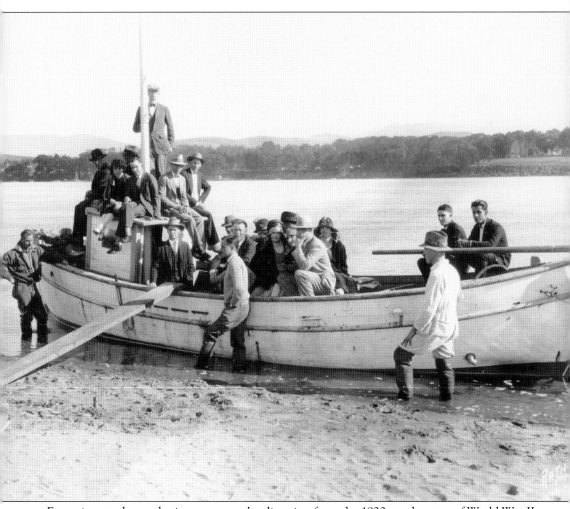

Excursions to the sand spit were a popular diversion from the 1920s to the start of World War II.. Several water taxis were available to take visitors on a tour around the bay or over to the "spit" for a picnic. This one was owned and operated by three expatriate Englishmen, Tommy Thomas (standing, center), Basil Jackson (standing, right), and Sydney Nichols (standing, left). Their fares are unidentified except for one, Clyde Jones, who is seated behind Thomas. Clyde was a local auto mechanic. (Courtesy Juanita Tolle.)

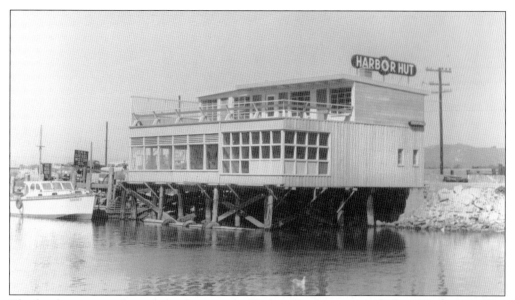

The first business on the embarcadero was the Harbor Hut Restaurant. Evelyn Whitlock and her friend, Delores Mesquit, established it in 1948. They purchased a military surplus Quonset hut and had it set up on the newly opened embarcadero. The building was smaller than a two-car garage and had seating for nine. Many locals have fond memories of the fine homemade foods sold there. In 1983, the business moved across the street to the building shown here. (Courtesy Wayne Bickford.)

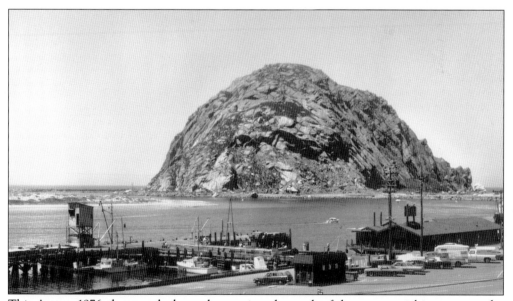

This August 1976 photograph shows the continued growth of the commercial interests on the embarcadero. The tower on the south "T" pier houses conveyor equipment to off-load small fish, such as sardines and smelt. The building to the right is the Great American Fish Company, a restaurant built in 1976. (Courtesy Wayne Bickford.)

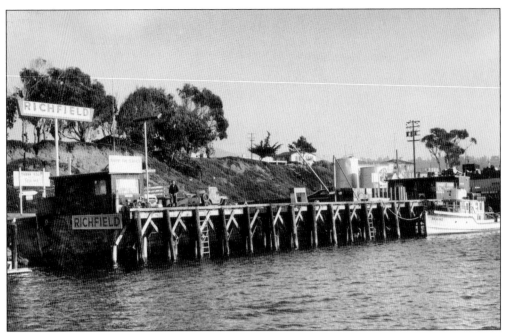

The growth of the commercial and sportfishing industries supported many auxiliary businesses. The Richfield fuel dock was a familiar site to fishermen and a welcome addition to the embarcadero businesses. (Courtesy Wayne Bickford.)

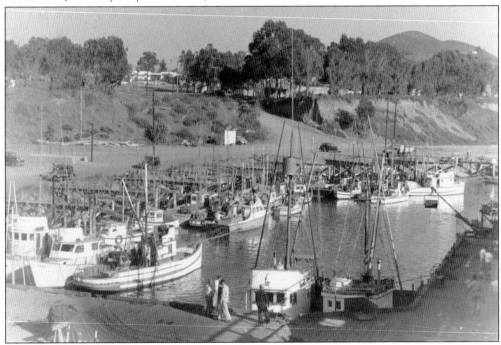

This c. 1950 photograph was probably taken by Glen Bickford. The embarcadero is complete, and the fishing fleet fills the pier, indicating that World War II is over and the naval base has been abandoned. That is Beach Street, at upper center, which has changed very little. Missing only are the businesses that now crowd the bluff and line the edge of the bay.

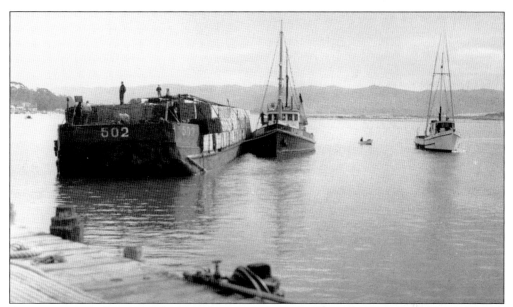

From time to time larger vessels would show up in port. This barge, being nudged toward the dock by a fishing vessel, appears be loaded with lumber. Commercial deliveries of this size are rare in Morro harbor. This 1954 picture likely depicts a delivery of materials for the PG&E power plant, then under construction. (Courtesy Juanita Tolle.)

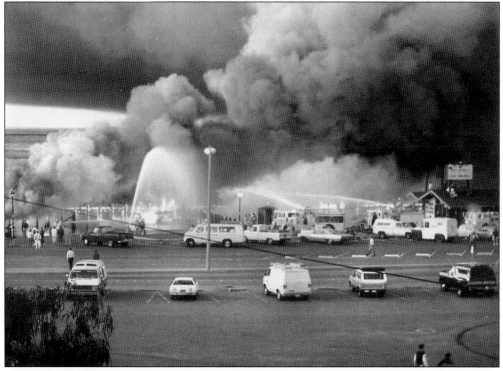

Unfortunately, Morro Bay has had its share of disasters. On the morning of December 1, 1988, fire consumed the South "T" Pier. One woman died and several people were injured. This shot was taken from the bluff just south of Beach Street. (Courtesy the *Sun Bulletin*.)

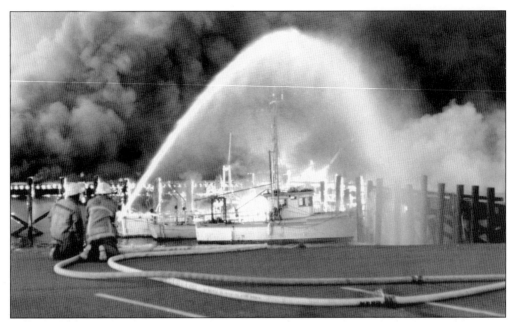

It was a fast-burning, dangerous fire because of the creosote preservative in the wood itself and all the fuel on the boats. In all, 11 neighboring fire agencies responded to assist the Morro Bay Fire Department. At the height of the blaze about 4,000 gallons of water per minute were pumped into the fire. (Courtesy the *Sun Bulletin*.)

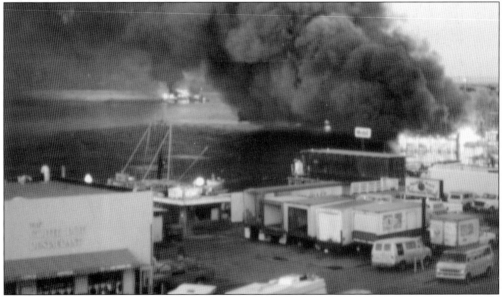

Of the 22 boats tied to the pier and each other that morning, 13 were lost or damaged. The other 9 were saved by the efforts of the local fire department and commercial fishermen. The *J. C. Freese 3*, a commercial construction barge, was saved when its lines burned through and it floated away. Four of the six top fire officials were out of town that morning, which left fire engineer Mike Pond in charge. Through his efforts, and those of all the agencies, the fire was confined to the pier area and the Great American Fish Company restaurant was saved. Mike Pond is currently fire chief in Morro Bay. (Courtesy *Sun Bulletin*.)

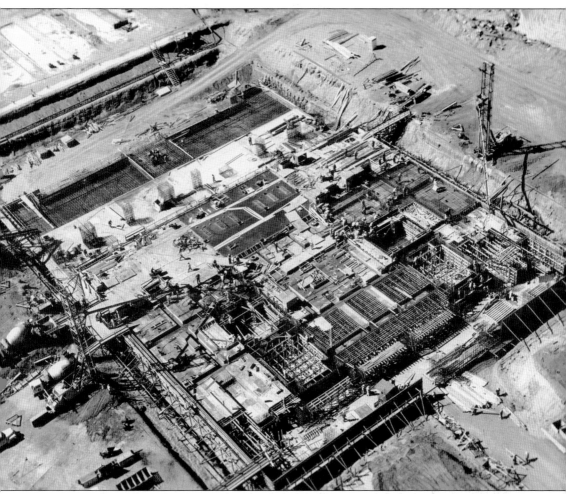

After the navy left Morro Bay, they gave the land back to local officials to be used "for the public good." As Morro Bay was not yet incorporated, the decision for use of this land was left to the county supervisors. In the early 1950s, they sold 140 acres to Pacific Gas and Electric Company for $44 million. In 1953, construction began on an electricity-generating plant cooled by water from the bay. By any measure, it remains the largest construction project ever undertaken in Morro Bay. By 1953, construction was well underway on the foundations for the Unit 1 and 2 building, pictured here. (Courtesy Duke Energy.)

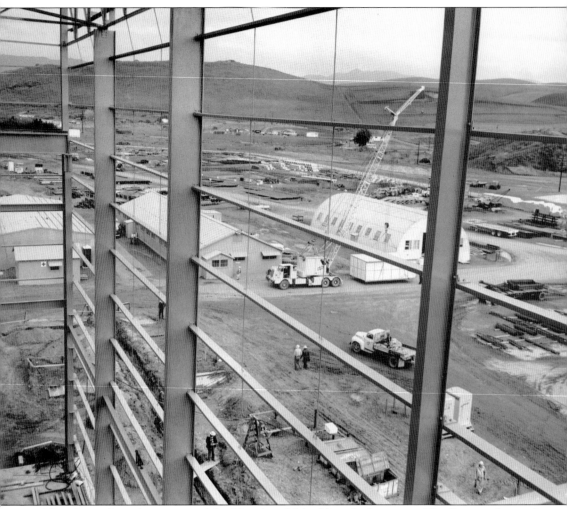

This shot is from the interior of the Unit 1 and 2 building, looking east. The Quonset hut and buildings outside seem to have been left all over the navy base. The roads behind the crane top are the Harbor Tract development, now on the east side of what would become a four-lane Highway 1. PG&E originally had plans for as many as 12 generating units, but only four were ever built. Despite its location in the heart of Morro Bay's waterfront, the plant provided an economic base for the town and was, in part, responsible for Morro's incorporation in 1964. (Courtesy Duke Energy.)

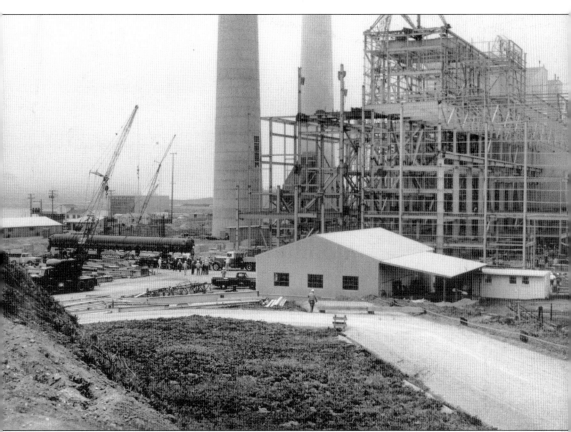

Units 1 and 2 came on line in 1955 and 1956. By the time this picture was taken in August 1961, construction of Units 3 and 4 were well under way. With some modernization over the years, the plant now has a capacity of 1,002 megawatts, which can provide power for about 10,000 homes on a summer day. Note the long steam drum on the left. Large and heavy equipment was brought by rail to just west of San Luis Obispo, and then to Morro Bay by truck. Many local contractors benefited from this project. Local cement contractor Wayne Bickford provided cement for two of the three 475-foot stacks. (Courtesy Duke Energy.)

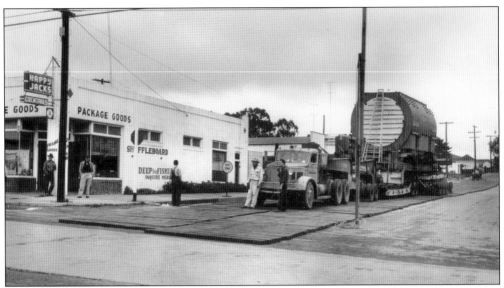

Until the 1970s, a Southern Pacific rail spur existed about eight miles out on Highway 1 toward San Luis Obispo. It was built during the war years to serve Camp San Luis during World War II. The spur was used by PG&E for delivery of heavy equipment used at the Morro Bay plant. Where the rails ended the equipment was put on multi-wheeled trucks, and planks were then laid on the highway to protect it. A convoy of trucks and men would pick up the planks behind the load and replace them in front as it made its way to the harbor. Here, the four-ton stator, or steam turbine, passes Happy Jacks on Harbor Street. (Courtesy Wayne Bickford.)

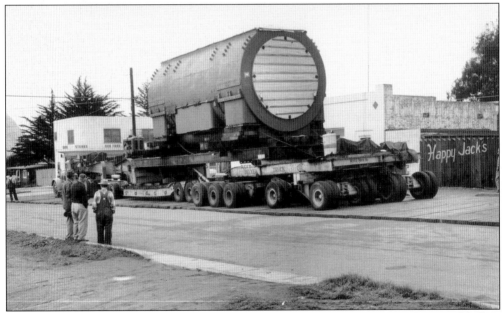

Extra tractors were tied by cable to the rear when the load began its way down the steep bluff on Harbor Street. This author was allowed out of school to watch the process. It was a damp and foggy day, and with the slick streets tensions were high as they began this last, dangerous part of the trip. Each time it even looked like a car would try to come up the hill, several men would run towards it waving their arms and shouting, "No! No! No!" (Courtesy Wayne Bickford.)

Four
THE BACK BAY

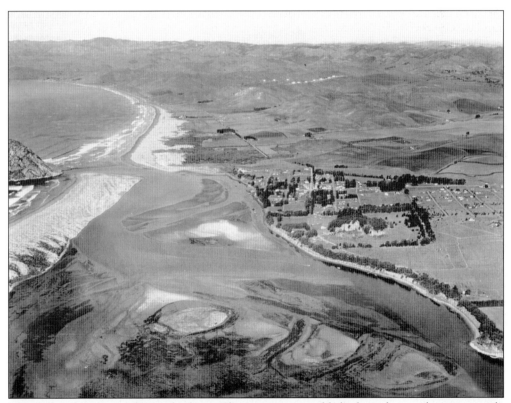

Morro Bay is just over four miles long. The town was established on the northernmost mile or so of this bay. That left the bulk of the bay, south to Baywood Park and Los Osos, open for exploitation. Fortunately for our generation, natural, economic, and political events conspired to keep this resource relatively natural. This 1931 view shows most of the bay, with White's Point in the lower left where the natural history museum is today. Note the open north channel and the strong wave action in front of the rock. (Courtesy Historical Society of Morro Bay.)

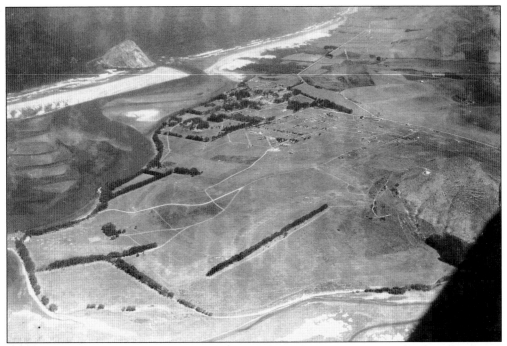

In the late 1920s, a nine-hole golf course was built by real estate interests on land south of town (see Chapter 10). In this 1941 photograph, the clubhouse is visible on the far left. Note how Kings Avenue extended across the farmland that would eventually become an extension of the golf course. The land at the bottom left would become the state park campground. (Courtesy Juanita Tolle.)

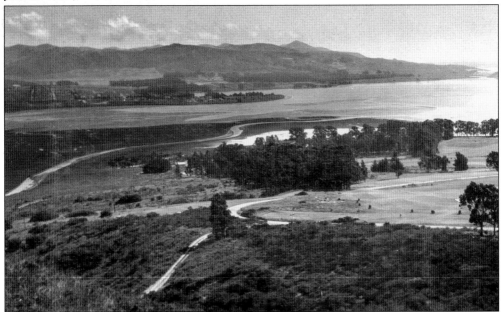

In this southwest view, taken from Black Hill, the upper part of the course is still undeveloped, which dates the picture prior to 1951. Baywood Park is across the bay to the left of center and Los Osos and the Montana de Oro portion of the state park are to the right. (Courtesy Juanita Tolle.)

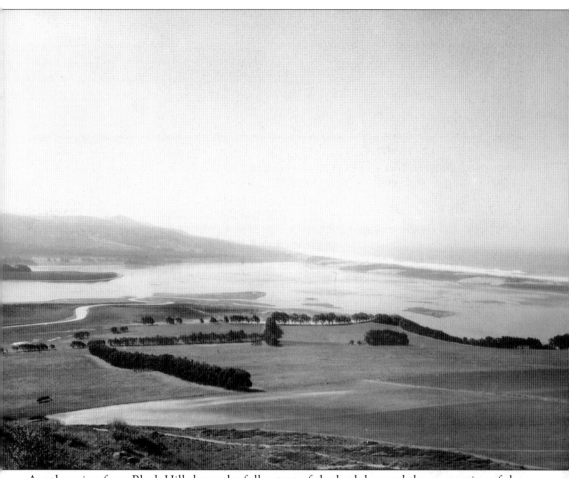

Another view from Black Hill shows the full extent of the back bay and the connection of the sand spit to land near what is today's Montana de Oro State Park. No development of the golf course, which began in 1937, is seen. The strip of water behind the row of trees is a natural lagoon. It would become the present-day State Park Marina. White's Point is at the right end of the row of trees. (Courtesy Juanita Tolle.)

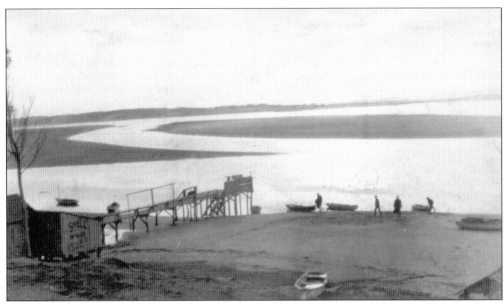

These views of the back bay both show Sylva's Wharf. The bay in this area has always been shallow, although it is constantly changing. The above picture, taken in 1917, shows the mud flats exposed at low tide. These tidal areas are home to many species of marine life and have been used commercially (see Chapter 6). The image below, dated 1928, shows the bay at high tide. This mood of the bay is perfect for nature excursions by canoe or kayak. (Photograph above courtesy of Pat Nagano; photograph below courtesy Juanita Tolle.)

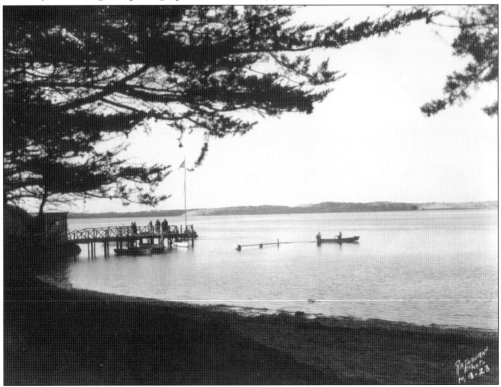

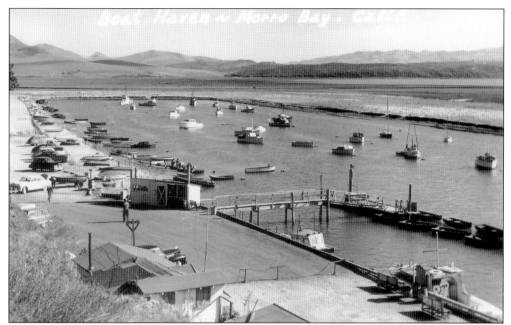

In 1949, real estate salesman, golf and country club manager, and expatriate Scotsman William "Bill" Roy received permission from the state park to build a small marina near the clubhouse. This postcard view from the early 1950s shows the result. Bill and his circle of friends had dreams of Morro Bay becoming a major national port, but it was never to be. (Courtesy Historical Society of Morro Bay.)

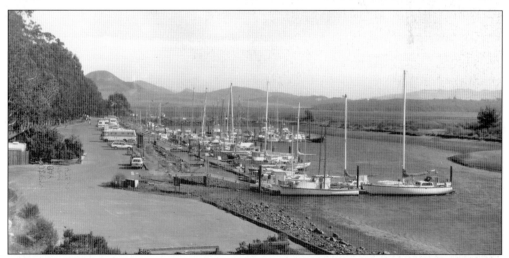

This is a more modern view of the marina, perhaps in the late 1980s. The land in the background is the Morro Bay National Estuary. Fed by the Chorro and Los Osos Valley creeks, it is the third largest estuary in the nation. Morro Bay is designated a bird sanctuary and the estuary is home to more than 150 species of birds. All of the land would eventually become part of the state park. (Courtesy Historical Society of Morro Bay.)

The marina area has always been a quiet and peaceful place to visit. This photograph, from the Roy collection, shows the eastern end of the marina before development. It was used in the late-1920s real estate advertising campaigns. (Courtesy Juanita Tolle.)

Five
FARMING THE VALLEYS

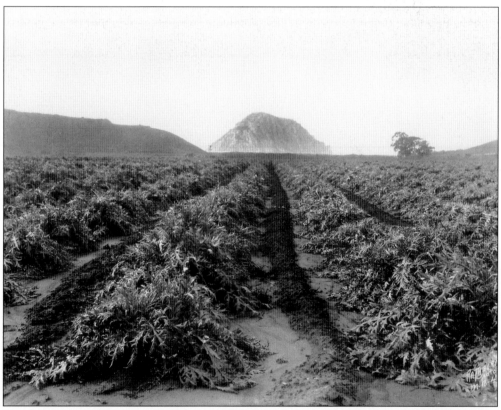

The fertile lands in the coastal valleys supplied sustenance for the townsfolk and employment for many. Here, on the Enos ranch in the Morro Creek valley, George Nagano was the first to grow artichokes. The sandy, rich soil and the temperate climate were ideal for a long growing season. Many crops were grown in the area in addition to artichokes, including flowers for seed, hay for livestock, peas, beans, and sugar beets. (Courtesy Juanita Tolle.)

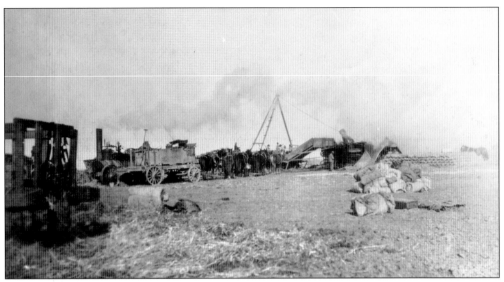

One of Morro Bay's early citizens passed on his pioneering ingenuity to the second generation. Mathias Schneider's eldest son, John, was the first to mechanize threshing and bailing operations. These turn-of-the-century photograph postcards show his equipment in operation. (Courtesy Historical Society of Morro Bay.)

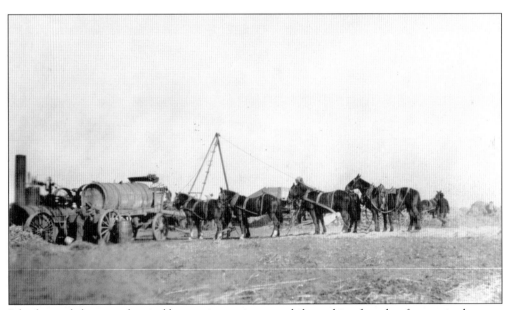

John learned about mechanical harvesting equipment while working for other farmers in the area. He purchased two machines, made his own improvements, and began working farms throughout the area. (Courtesy Historical Society of Morro Bay.)

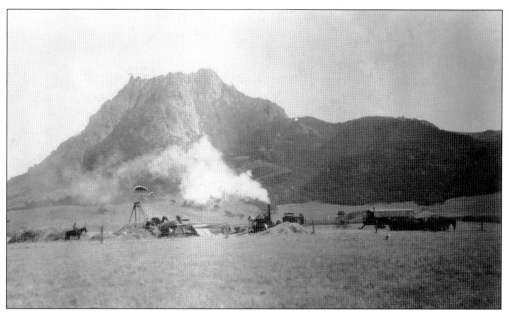

John Schneider's operation is pictured here on Waldo Bonetti's "Old Adobe" ranch in the Chorro Valley. Hollister Peak looms over the steam-powered machinery. The steam only provided power for the equipment that was mounted on horse-drawn wagons. (Courtesy Historical Society of Morro Bay.)

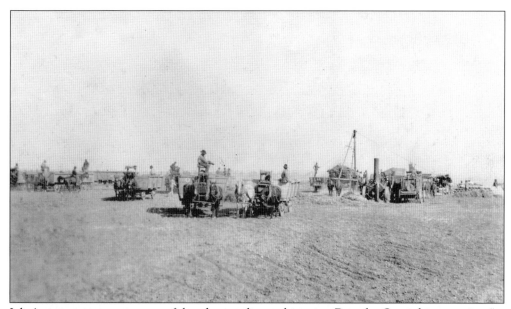

John's venture was very successful and, according to historian Dorothy Gates, his operation "at one time consisted of 49 men and his machine was pulled by 49 horses." (Courtesy Historical Society of Morro Bay.)

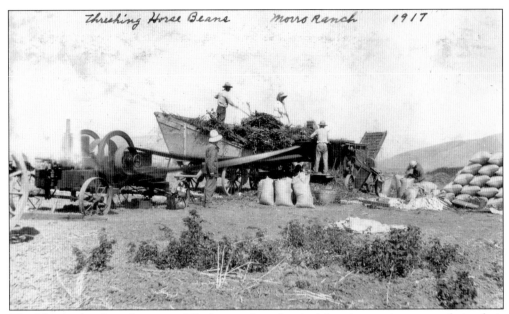

The Nagano brothers (see page 18) also used mechanical farming equipment early in their operation. Here in 1917, their crew is threshing horse beans with a steam-powered machine. Note the long belt connecting the thresher to the steam engine. (Courtesy Pat Nagano.)

Sweet peas, grown for seed, were one of the Naganos's earliest crops. Here, fast-moving ranch hands fling the cut pea plants into the thresher. The resulting seeds were shipped to Europe, where the flowers were quite popular. (Courtesy Pat Nagano.)

The first crops were taken to customers in town and around the area by horse-drawn wagon. By the 1920s, however, the Naganos had this truck and tractor and could deliver their produce to the local markets and the railhead in San Luis Obispo. (Courtesy Pat Nagano.)

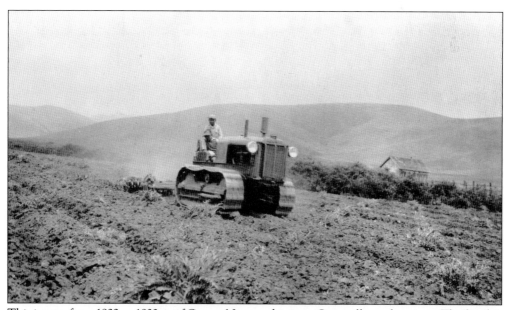

This image, from 1932 or 1933, is of George Nagano driving a Caterpillar-style tractor. The family's house can be seen in the background. (Courtesy Pat Nagano.)

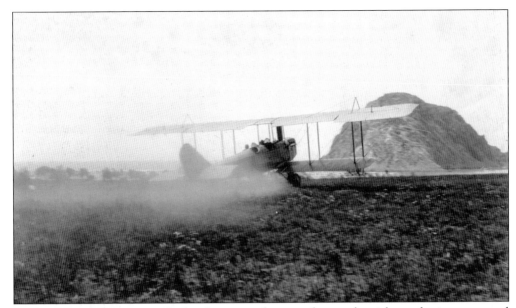

By the 1930s, the Naganos and other farmers in the area often used aerial crop dusting to control insects. The small planes would take off from what was to become the Domenghini airfield at the south end of town. They would fly low over the first small range of costal hills and, as pictured here, drop their chemicals close to the crops. (Courtesy Pat Nagano.)

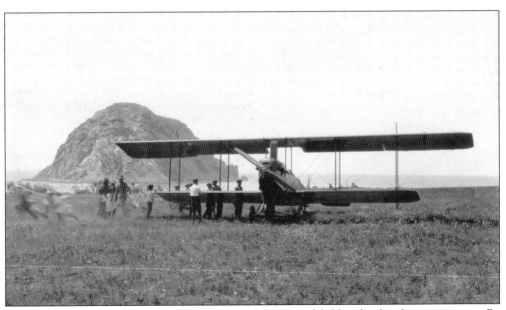

Occasionally, they would have to land in a hopefully unused field, either by plan or necessity. By the late 1950s, urban growth, growing government regulation, and cost had all but put an end to this method of pest control and fertilization. (Courtesy Pat Nagano.)

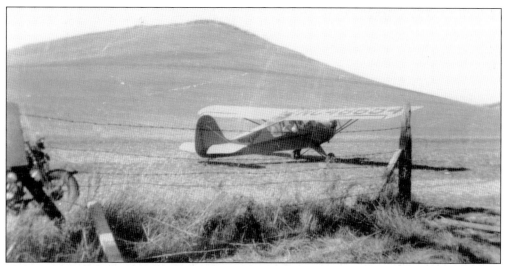

The very end of the Domenghini airstrip can be seen here, just in front of the motorcycle wheel. Louis, the eldest son of Angelo and Theresa, was responsible for creating this strip in the mid-1940s mainly out of his love for flying. He owned and flew a small plane and built a hanger for it at one end. The field did provide a landing site for other private pilots and a base for crop-dusting operations. (Courtesy Betty Domenghini.)

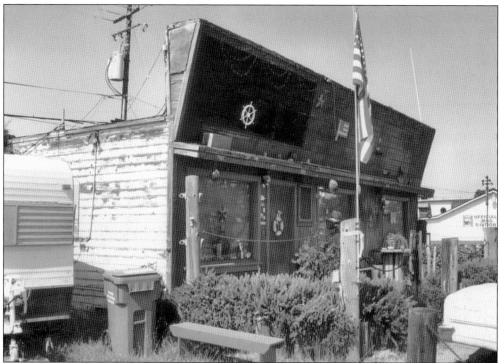

The airstrip was located at the southern entrance to Morro Bay, just east of the then two-lane Highway 1, now Quintana Road. Across the old highway from the airstrip was the Airport Café. That building, depicted in this modern photograph, is currently being used as a private residence. The airstrip remained in occasional operation until the late 1950s when the Domenghinis sold the property to the state for the new freeway. (Courtesy Thom Ream.)

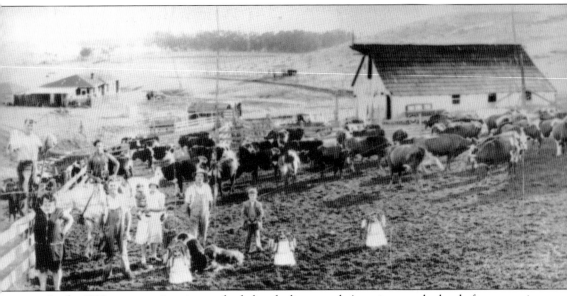

In the 1920s, as many immigrants had already discovered, America was the land of opportunity. That hope and dream brought Angelo and Teresa Domenghini to Morro Bay in 1922. By 1927, they had purchased a large part of the San Bernardo land grant at the southeast entrance to town. There they raised five children and established a dairy and cattle farm. Pictured here, from left to right, are Genito Brughelli, Jenny Bognuda (Teresa's sister-in-law), Joe Bognuda (on the horse), Matteo Bognuda, Teresa (holding Roy with Americo at her side), Louis Bognuda, and young Louis. The three white "angels" in the foreground are milking machines. (Courtesy Betty Domenghini.)

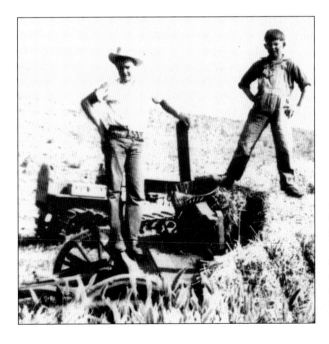

Around 10 years later, Americo and Roy have grown into strapping young farmhands. A large family was definitely an advantage for a farming operation of this size. The boys are standing on the hay wagon. Note the 1920s Caterpillar-style tractor. (Courtesy Betty Domenghini.)

The large operation required considerable feed for the livestock. A major part of the dairy operation was the growing of feed hay. This 1967 picture shows the crop safely stored for winter. (Courtesy Betty Domenghini.)

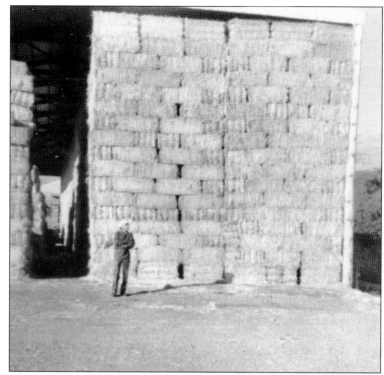

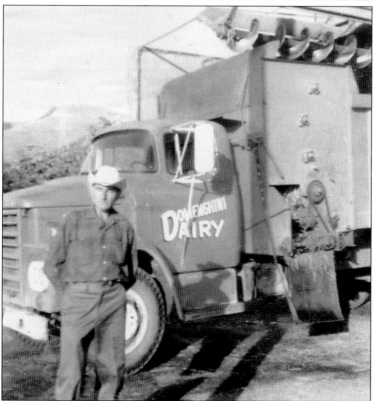

The farm had the latest mechanized equipment by the late 1960s. Eduardo Bettrametti, Angelo's nephew visiting from Switzerland, poses by this mechanical bailer. (Courtesy Betty Domenghini.)

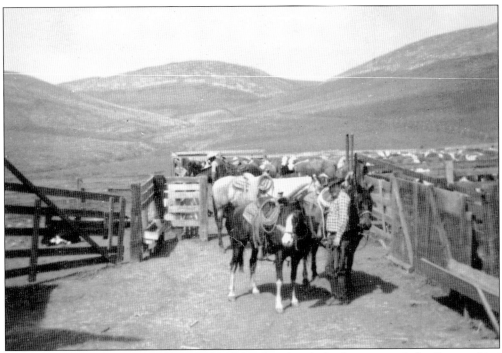

Manuel Souza, of another well-known local family, often helped out around the Domenghini ranch, such as in this 1969 roundup. (Courtesy Betty Domenghini.)

The latest addition to Morro's farming industry began in the early 1970s. Local veterinarian Dave Wixom and his wife, Margaret, planted the first avocado orchard in 1972 in the Morro Creek Valley. This 1975 image shows a planting on the left with a second just completed on the right. These orchards and others in the area remain in production. (Courtesy Ron Kennedy.)

Six
Scenes of a Fishing Village

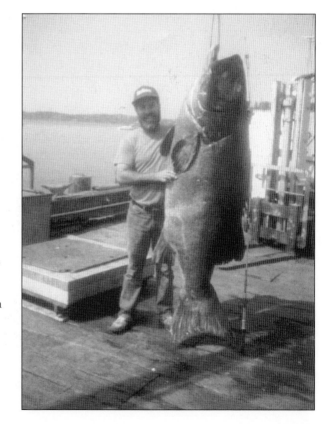

Morro Bay's story is inextricably tied to that of the fishing industry. Whether a sport or commercial fisherman, a former abalone diver, or simply a lover of good seafood, a large part of Morro Bay memories are connected to the sea and its bounty. Pictured in 1995, Gary Blodgett smiles next to a 400-pound black sea bass (now an endangered species). (Courtesy Jean Leage.)

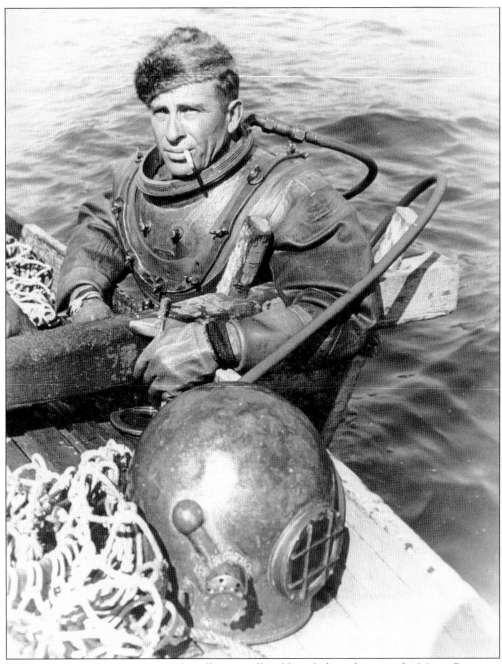

Delmar "Foosie" Reviea was one of small group of hard-hat abalone divers in the Morro Bay area. Commercial abalone diving was exhausting and dangerous work, especially in the early years of the industry. A diver had to wear several layers of clothing to ward off the cold before putting on diving equipment weighing nearly 100 pounds and 50 or 60 pounds of weights. This Bickford photograph, taken August 23, 1938, shows the old-style helmet (before safety innovations) and the net basket used to collect the catch. (Courtesy Wayne Bickford.)

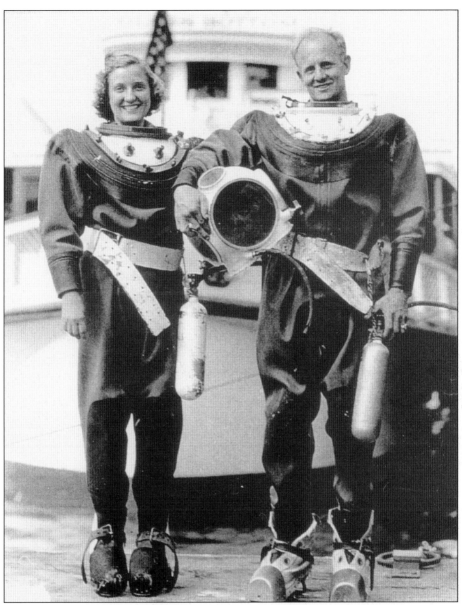

Two of the major players of the hard-hat diving community were Alfred and Norma Hanson. Al began his diving career around 1945 with Barney Clancy, the Pierce brothers, and others in Morro Bay. He was present the day Bill Pierce was killed in a diving accident. This event inspired Al to invent several safety innovations. He added phones so divers could communicate with the deckhands and installed a check valve in the diver's helmet to seal in any remaining air if the hose was cut. He also invented the "bailout bottle," which provided air and inflated the suit, raising the diver to the surface. Norma was a pioneering female who earned respect not only from her male counterparts in the abalone industry, but as an entertainment diver under the glass-bottom boats at Catalina Island and as a construction-dive crew chief as well. Both Hansons worked as divers and advisors for Walt Disney Studios, starting with *20,000 Leagues Under the Sea*. They retired from the industry as chief divers for the Port of Los Angeles in 1988 when Al was 88 years old. (Courtesy Steve Rebuck.)

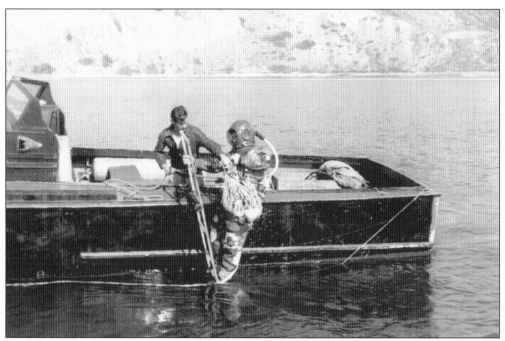

Commercial abalone diving was done from small boats. Pictured here is the *Nina*, one of Barney Clancy's "black fleet," operating out of Morro Bay around 1957. A three-man crew, consisting of a diver, the diver's tender, and the boat operator were standard practice. (Courtesy Steve Rebuck.)

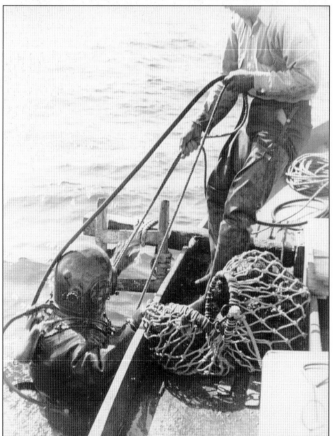

The diver would put on the heavy suit over several layers of clothes. The tender would check his equipment and add 15 pounds of chest weights over his shoulders. With an abalone bar in one hand and collection nets in the other, the diver would climb down the short ladder and the tender would lower him via rope and air line. (Courtesy Wayne Bickford.)

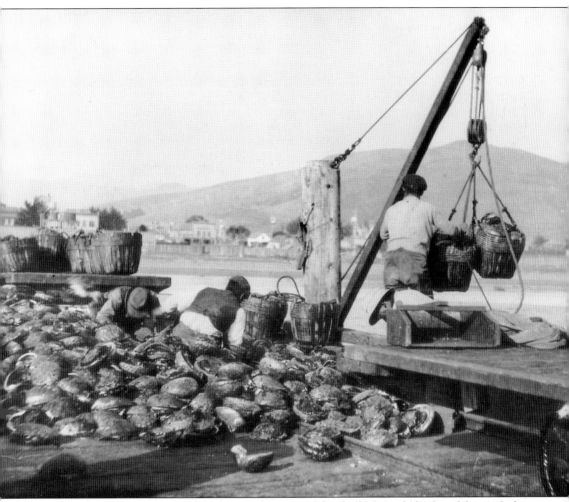

In the heyday of the abalone industry, several species of the shellfish could be found from Alaska to Mexico. The red abalone was most abundant in this area. Divers would bring the harvested abalone to the dock each day. Between 1930 and 1960, Morro Bay was the principal processing port. Some divers owned or had an interest in a processing plant. Others sold to the highest bidder. In this 1930s photograph, baskets of abalone are being hoisted onto a pier, probably at Cayucos, about six miles north of Morro Bay. (Courtesy Juanita Tolle.)

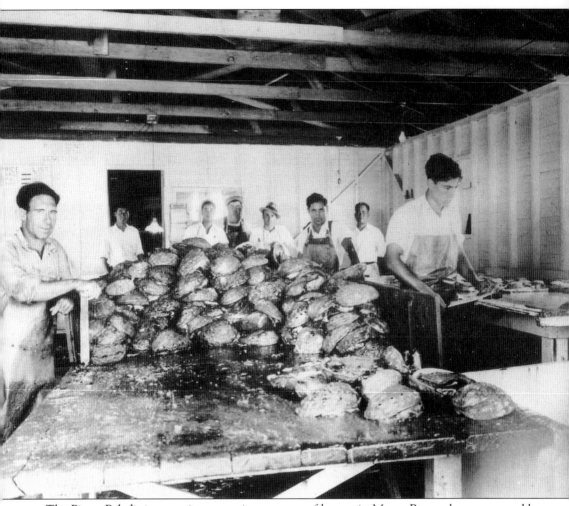

The Pierce-Paladini processing operation was one of largest in Morro Bay and was managed by Dutch Pierce. Six of the Pierce brothers were divers, as were eight Pierce cousins. Other divers also sold their catch to the Paladini Company, and many of them worked in the plant from time to time. Some of the Pierce brothers and friends are shown here in the early years of the operation, probably around 1932. Pictured, from left to right, are Bill, unidentified, Frank Brebes, Karl (Boog), Adrian (Dutch), Les, Frank Sorashi, and Charlie. (Courtesy Steve Rebuck.)

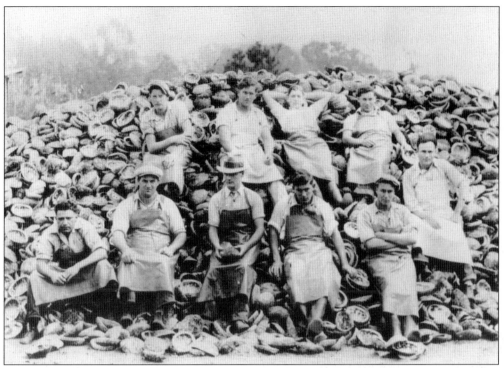

More members of the Pierce "gang" pose outside the Monterey street plant. Pictured here, from left to right are (front row) Frank (Pepper) Herrera, Karl Pierce, Eddie Pierce, Charlie Pierce, Bill (Flop) Kester; and (second row) cousins Walt (Blub) Pierce and Tom Pierce, Carl Tonini, Les Pierce, and A. R. (Dutch) Pierce. Many of the area's divers were given nicknames by the Pierces, which some are still known by to this day. (Courtesy Steve Rebuck.)

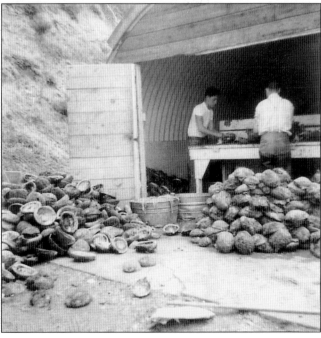

The Pierce brothers managed a plant for the national seafood processor, A. Paladini and Company. Other processors included Barney Clancy, Betty Jamison, and Orvil Leage. This July 1952 picture is of Barney Clancy's operation in a Quonset hut at the corner of Beach and the Embarcadero. (Courtesy Steve Rebuck and Barney Clancy.)

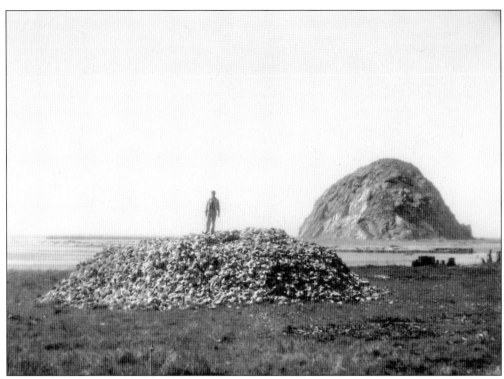

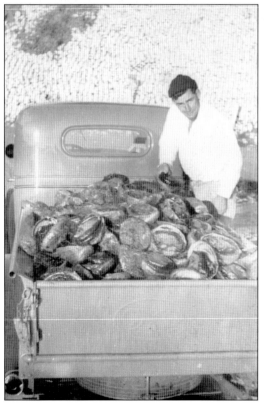

Paul Lambert stands here atop a large pile of abalone shells. In 1957, according to state records, 5.4 million pounds of abalone were harvested in California. This pile of shells remained at the side of Highway 41, about two miles east of town, for many years. (Courtesy Paul Lambert.)

The abalone harvest declined steadily after late 1955. The reasons are many and complex, and agreement on cause, effect, and cure is still illusive today. Many think the large piles of shells depicted in these photographs demonstrate overfishing. According to Steve Rebuck, author and industry consultant, published government studies show red abalone landings averaging 2 million pounds a year for more than 50 years. In this 1950s photograph, Charlie Pierce unloads processed shells. (Courtesy Steve Rebuck.)

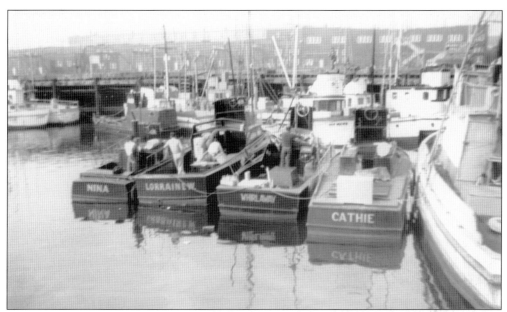

These abalone boats were known as the "black fleet," owned by processor Barney Clancy, which included the *Whirlaway*, the *Cathy*, the *Lorraine W.*, and the *Nina*. The fifth boat, in the foreground of this 1955 photograph, is the *Rosey*, owned by Bob Kirby. According to Steve Rebuck, although he was not one of Clancy's crew, Kirby liked to hang out with the "black fleet." (Courtesy Steve Rebuck and Barney Clancy.)

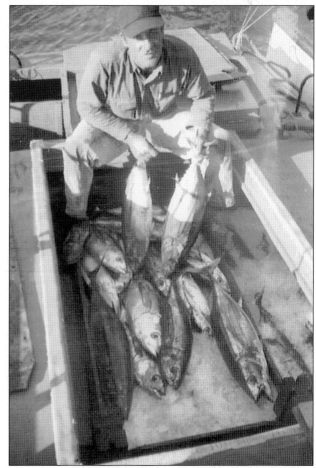

Following World War II and the harbor's opening, commercial fish catches began to surpass that of abalone divers. All types of angling methods were used and the harbor was often active each evening as fishermen returned with their catch. Commercial fisherman George E. Rebuck is pictured here, around 1955, aboard the *Laura Bell* with her hold filled with Albacore tuna. (Courtesy Steve Rebuck.)

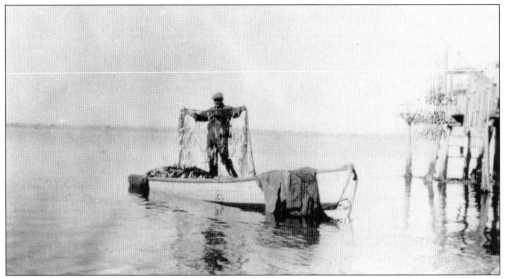

Several kinds of net fishing, for both commercial and sportfishing, have been used in Morro Bay. Gill-net fishing uses small to medium mesh nets hung vertically in the water where fish swim in and are trapped by their gills. This 1925 photograph shows Al Sylva displaying his harbor smelt catch. (Courtesy Adele Sylva Costa and Jan Cooper.)

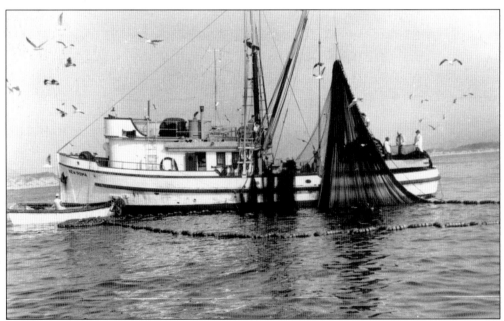

Here, the *New Roma* hoists the day's purse seine catch. This commercial fishing method uses a large net, weighted on the bottom and open on one or more sides, which is deployed in the open ocean. Fish swim into this large "purse" and are caught as the net closes when it is hoisted out. (Courtesy San Luis Obispo County Historical Society.)

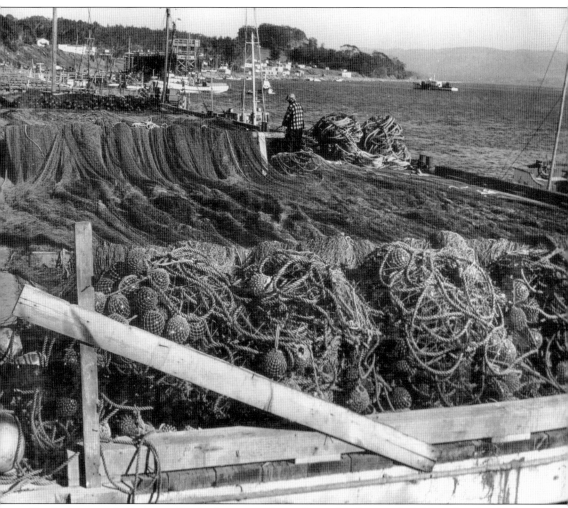

Shark nets were laid out on the dock or on racks to dry and to be mended. Note the glass balls used as floats on the upper edge of the net. These colorful balls were once a common find among the shells and driftwood on area beaches. (Courtesy Wayne Bickford.)

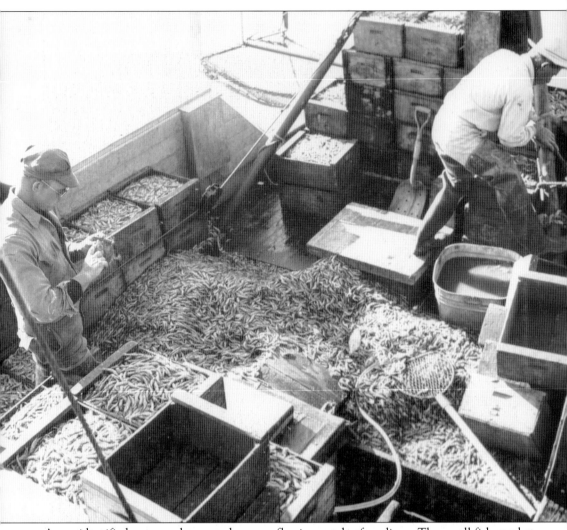

An unidentified crew works around an overflowing catch of sardines. The small-fish market, including sardines, herring, and anchovies, has long been strong on the California Coast. By 1951, at least a dozen sardine boats operated out of Morro Bay. In the early 1960s, conveyer machinery was installed on both piers to expedite the off-loading of the catch. (Courtesy Wayne Bickford.)

There is historical evidence that the oyster was a favorite food of Morro Bay's native Chumash Indians. The native California oyster was to be found locally into the 1930s. As supplies of this delicacy began to dwindle, likely due to environmental causes, the mud flats of the back bay were leased for a commercial oyster farm. From 1953 until they sold the business in 2001, the Leage family grew Pacific oysters in the mud flats off White's Point, pictured here. (Courtesy Jean Leage.)

The large mollusk, a delicacy for many, was raised from seed, or "spat," imported mainly from Washington State. Oysters grow in large groups or clumps. After about a year, the clumps are broken up and redistributed over the mud flats at low tide. (Courtesy Jean Leage.)

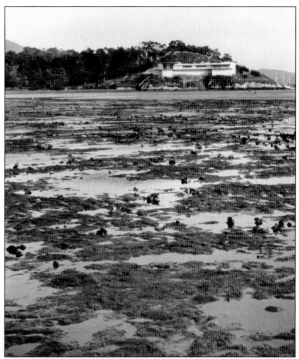

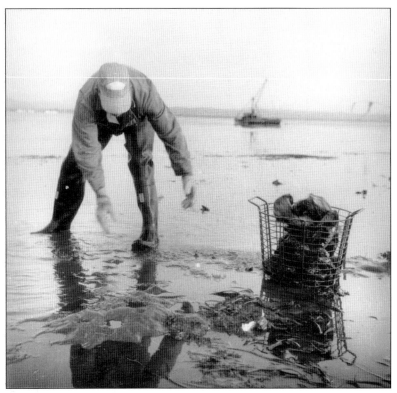

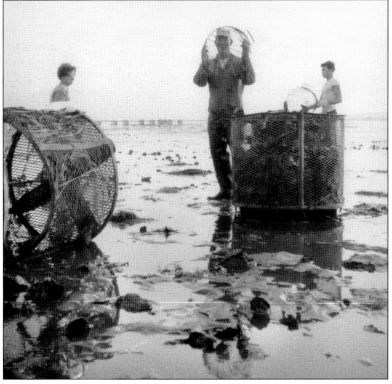

The Leage family's operation used the most modern techniques of the time. After growing in the bay for about three years, the oysters reached harvest size. These images (along with the upper image on page 86) show the harvesting steps. The crew, often family, would collect the shellfish by walking out on the mudflats at low tide—it was a difficult job. Boots would sink into the cloying, wet mud and the bay waters were chilly. The day's catch was placed in large wire baskets and left on the mudflats until high tide. (Courtesy Jean Leage.)

When the tide came in, the shellfish were rinsed in the bay several times to remove as much sand debris as possible. Then the full baskets were taken by short boat trip to the dock next to the processing plant. (Courtesy Jean Leage.)

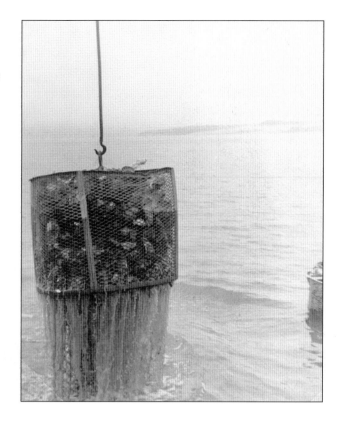

The Leages built this modern processing facility around 1956 designed specifically to prepare the oysters for market. The monorail crane extended over the dock and freshly harvested baskets of oysters were brought into the plant directly from the boats. (Courtesy Jean Leage.)

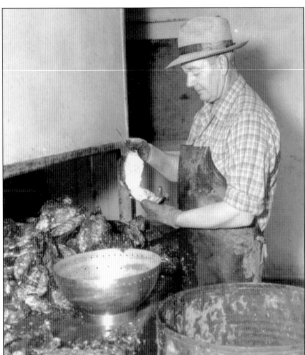

Inside the plant, the shellfish were opened and the oyster was removed from the shell, or shucked (as the process is called). Here, Orvill Leage gently removes the delicate mollusk. (Courtesy Jean Leage.)

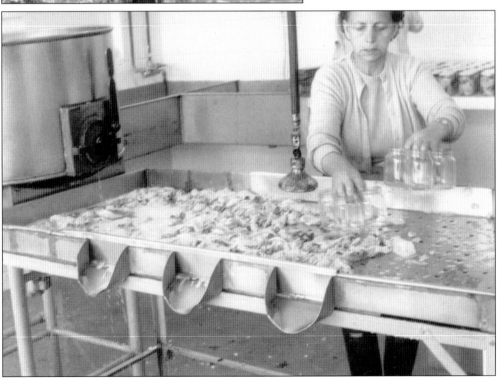

The next step is a gentle washing in the tub, pictured at left. The meat was then graded by size before being canned, frozen, or as Angie Leage is doing here (at right), placed in jars. (Courtesy Jean Leage.)

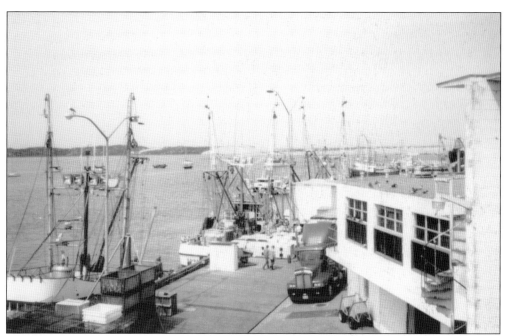

The completed shipment was shipped by truck, as seen in this 1970s-era photograph. (Courtesy Jean Leage.)

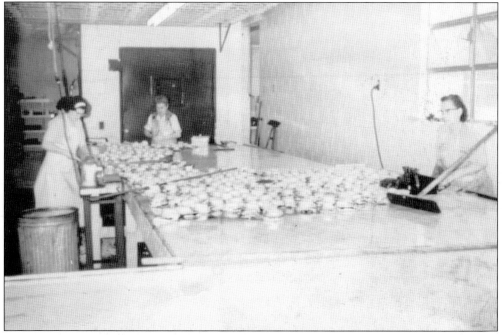

In addition to oysters, the Leages also processed some abalone. Like oysters, the abalone catch was brought into the plant. Meat was removed from the shells and allowed to "rest" on tables like these for 12 hours before being trimmed, sliced, and pounded to soften it. Abalone was then usually frozen. We see Agnes Leage again on the right, with two unidentified helpers preparing the abalone. (Courtesy Jean Leage.)

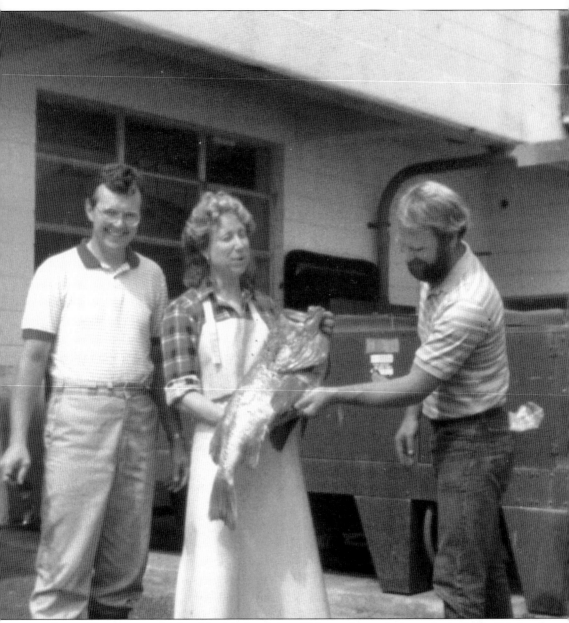
Pictured here is an example of the kind and size of fish caught on the party boats. Mike Pritchard and Sandy French show off a red rock, or cow cod, to an unidentified buyer around 1995. (Courtesy Jean Leage.)

Seven
THE WORLD WAR II COMMITMENT

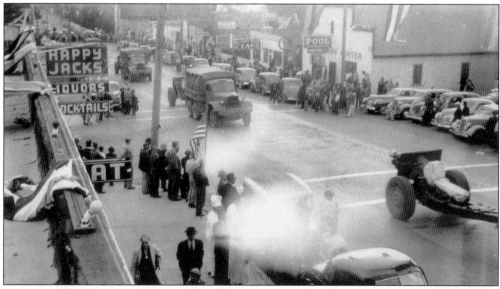

Like everywhere else in America, Morro Bay was transformed overnight on December 7, 1941. The response may have been even stronger than that of other small towns due to the community's proximity to the Pacific Ocean, its natural harbor, and the fact that Morro Bay already had a military base. In 1940, the navy established an amphibious training base on 100 acres of waterfront land. By the end of the war it would occupy more than 250 acres and provide many improvements to the town. In this damaged and undated photograph, the citizens turn out to honor the military. Note the recreation center (pool hall) across Harbor Street from Happy Jacks. This building burned down in 1942 (see page 108) and was replaced by the Circle Inn restaurant and bar, known today as Legends. Two doors down is the Cozy Nook café and next to it Frank Cardoza's Grocery. (Courtesy Historical Society of Morro Bay.)

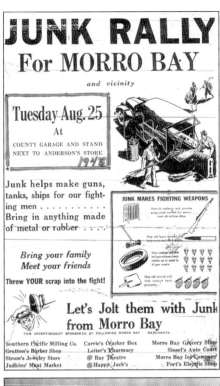

By 1943, home-front support of the war had become almost second nature. Junk rallies and bond drives were common, and each block had a citizen civil-defense warden to help enforce the nighttime blackout and other precautions. (Courtesy Historical Society of Morro Bay.)

Pictured here sometime after 1941 is the amphibious training base at Morro Bay. It was a navy coast-patrol training facility as well as section base. In 1943, it fell under the jurisdiction of the coast guard but was always known to locals as the "navy base." The improvements, which were later left to the town, include the two "T" piers, the creation of the large embarcadero in front of them, and strengthening and widening the fill between the rock and the shore. Note the Quonset hut barracks on the bluff, a portion of which is now occupied by the Veterans Memorial Building. The road at the bottom of the photograph is the two-lane Highway 1, which used to go through the center of town. Little Morro Creek Road intersects at the right, and what would become Quintana Road branches down to the left. (Courtesy Historical Society of Morro Bay.)

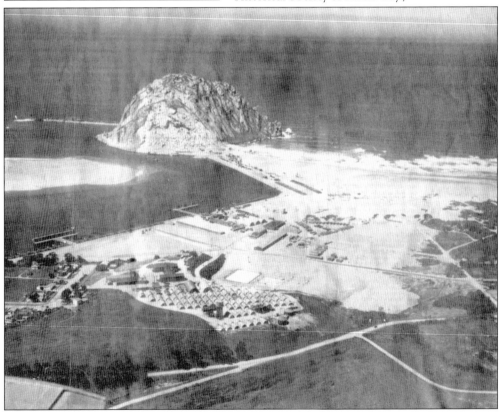

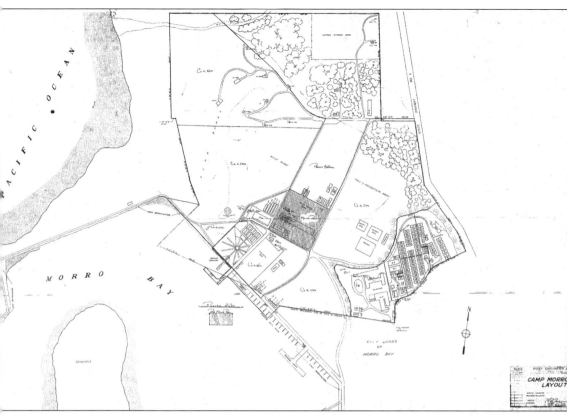

This map shows all the land that was used by the naval base. To the right of center, up on the bluff are the large administration buildings. Behind them are rows of Quonset huts, a couple of which still exist. The gray area in the center is the approximate location of today's PG&E power plant. Above center, branching roads and small buildings are visible. These were ammunition bunkers, located in high sand dunes. The author recalls many picnic lunches and childhood exploration of the area. It was taken over by PG&E, and fuel oil storage tanks were built there. This map shows the completed base with improved access to the Rock and the embarcadero, much as it is today. The second half of the "T" on the north pier was added before the end of the war. (Courtesy Historical Society of Morro Bay.)

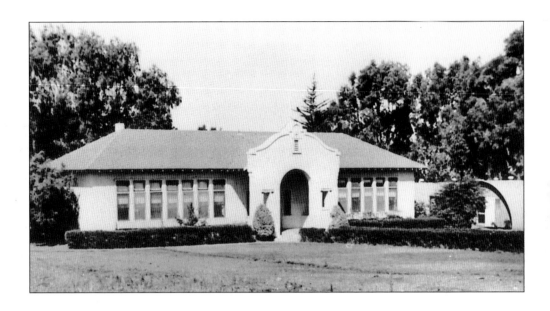

These buildings were located in the northwest corner of town, above the base. The above structure was built in the 1920s as a school (see page 119) and used until 1937. At far right is one of nearly 100 Quonset huts used as enlisted men's quarters. The letters on the sign below stands for "Tactical Training Unit—Amphibious Training Command." (Courtesy Historical Society of Morro Bay.)

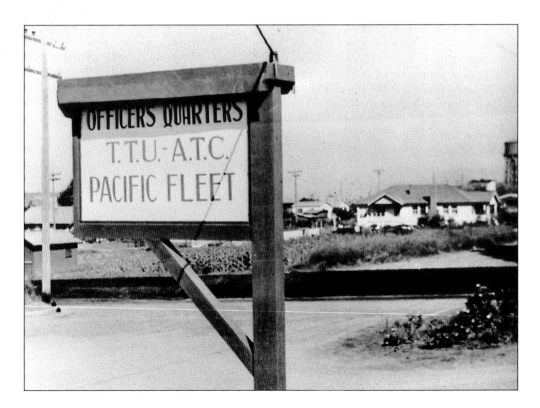

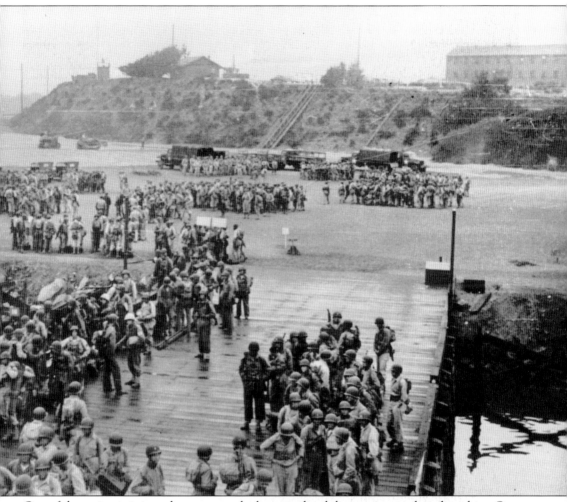

One of the major training advantages to the bay was the ability to practice boarding ships. One "T" and one "L" shaped (later modified into a "T") pier were constructed. On the south pier, a two-story scaffolding was constructed with a shear wall on the bay side. Trainees would assemble on the dock as in this image. Note the headquarters buildings on the bluff. (Courtesy Historical Society of Morro Bay.)

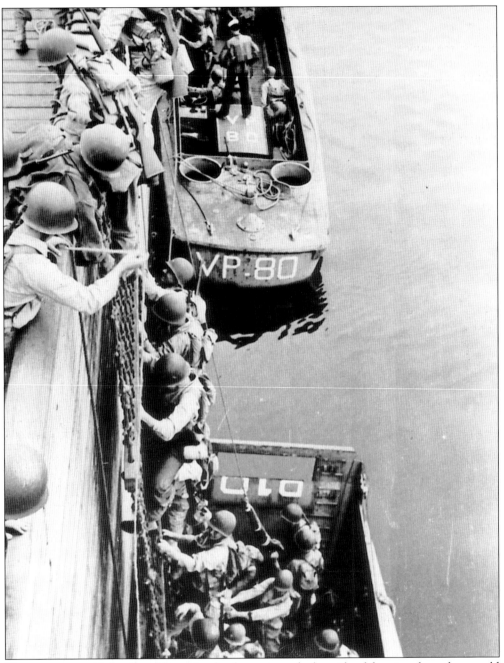

The trainees would then board boats for the short trip to the bay side of the pier where they would "assault" the side of it and climb chair or rope ladders up and over the top. (Courtesy Historical Society of Morro Bay.)

Many of these recruits had only been in the service a few weeks and many had little marine experience. Loaded with helmet, rifle, and various "ditty" bags, they had to push off from the small, bobbing boats, grab the ladder, and climb without getting stepped on, cutting up their hands, or falling in to the chilly bay waters. (Courtesy Historical Society of Morro Bay.)

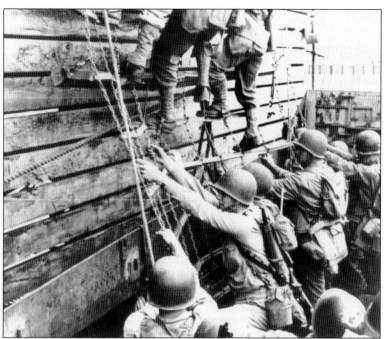

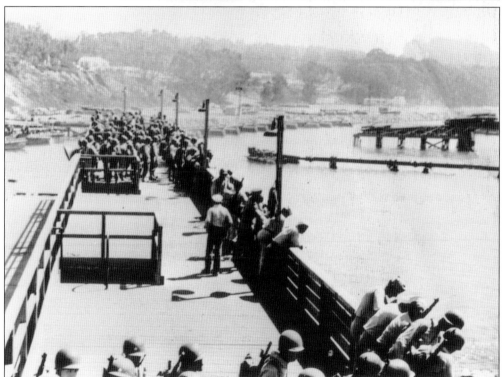

Once the exercise was over, the old military adage of "hurry up and wait" came into play. Although the view was excellent from that position, there was little to see other than the bay and the Rock. The railed structures to the left are stairways down to the pier. Another exercise involved running up and down them in full gear. (Courtesy Historical Society of Morro Bay.)

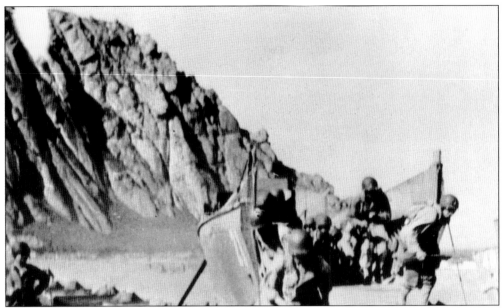

Assaults and landings were practiced on the beaches. A pedestrian trestle was constructed to the sand spit to facilitate this (see page 35). "Invasions" of the beach north of the Rock were common, however, this landing was on dry land. Note the beached landing craft and the prop holding it up. (Courtesy Historical Society of Morro Bay.)

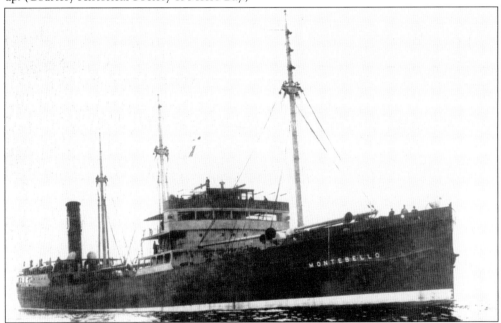

The most dramatic action of World War II in the Morro Bay area was the sinking of the *Montebello*. The Union Oil Company tanker was sunk in the early morning hours of December 23, 1942, presumably by a Japanese submarine. The 8,000-ton ship was struck amidships by a torpedo and sank in about 20 minutes just off Piedras Blancas. All 36 crewmen were saved. The Morro Bay-based tugboat *Alma* played a major part in the rescue as did many area residents. (Courtesy Historical Society of Morro Bay.)

Eight
SNAPSHOTS OF A SMALL TOWN

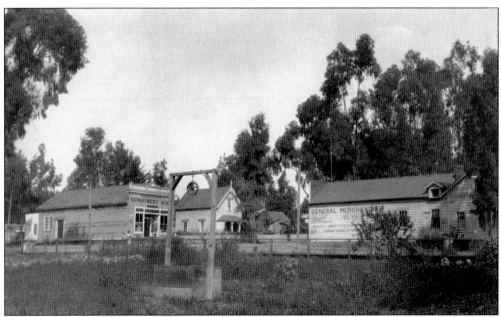

Not every town has two commercial centers. Morro Bay has the waterfront, or embarcadero, and it has a downtown. Before the freeway was built, Highway 1 ran through town as Fifth Street (now Morro Bay Boulevard) and then north on Main Street, out of town—this corridor has always been downtown. This photograph of the intersection, looking northeast, was taken within a few years of the town's formation in 1872. Maston's department store is on the left and Genardini's store on the right. The Schneider house can be seen behind the well that soon would be the site of Morro Bay's first hotel. The Mastons later had a grocery store about where the well is in this picture (see page 103). (Courtesy Historical Society of Morro Bay.)

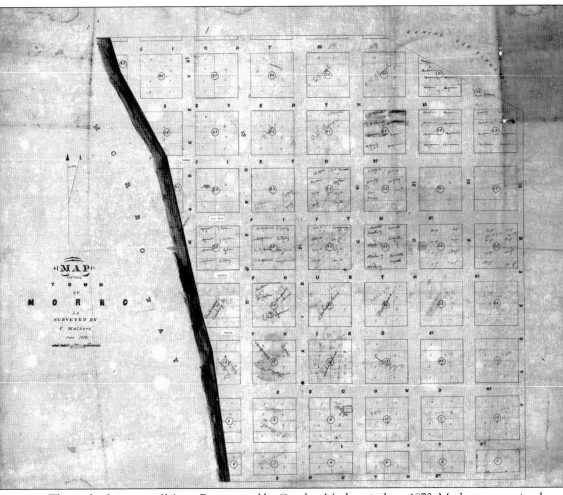

This is the first map of Morro Bay, created by Carolan Mathers in June 1872. Mathers was trained as a surveyor and met Franklin Riley while they were both living in Cambria. After Franklin acquired the land, they conceived to layout of the town together. As the various lots were sold, the names of the buyers were marked on the map, creating a veritable who's who of Morro Bay pioneers: A. B. Spooner, Schnieder [sic], C. T. Church, Stocking, Brown, and Mrs. Romo. (Courtesy Historical Society of Morro Bay.)

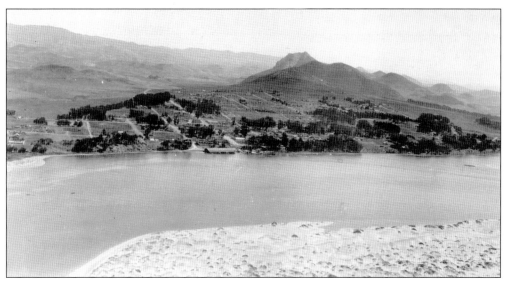

This view from the top of the Rock, taken around 1929 or 1930, shows the growing town. Note the lack of any embarcadero. The bay, seen here at high tide, comes right up to the bluff. The large building near the center is the saltwater plunge (see page 43). (Courtesy Wayne Bickford.)

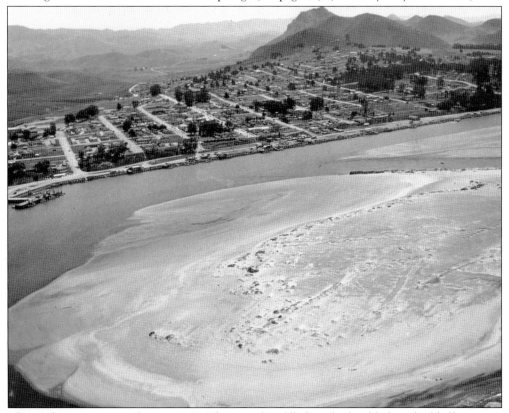

This is the same view, taken in 1949. The navy has filled in the land below the bluff, creating the embarcadero, and built the pier. Note that the pedestrian trestle to the sand spit, which was also built during the war, is already gone. (Courtesy Wayne Bickford.)

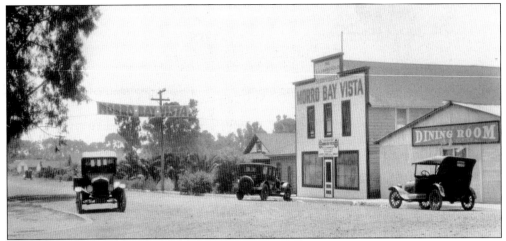

One of the major products of Morro Bay from 1900 to 1939 was real estate. The beauty and mild weather made it an easy sell. One of the many to capitalize on this was T. J. Lawrence and his Morro Vista Company. In the 1920s, he sold land on the upper heights, near the golf course that was built in 1928 (see Chapter 10). (Courtesy Juanita Tolle.)

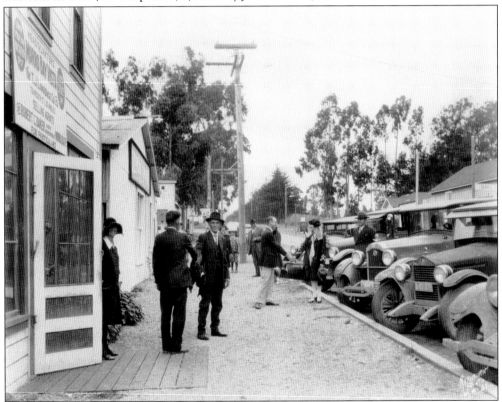

Lawrence and his associates advertised the beauty and tranquility of Morro Bay in San Joaquin Valley newspapers. This picture shows unidentified prospective clients who would make the long trip in their Model T's and A's to be wined and dined by Lawrence's head salesman, Robert Baker. Plagued by financial problems, Lawrence would sell the Morro Vista Company to Clinton Miller and Edward Murphy in mid-1928. (Courtesy Juanita Tolle.)

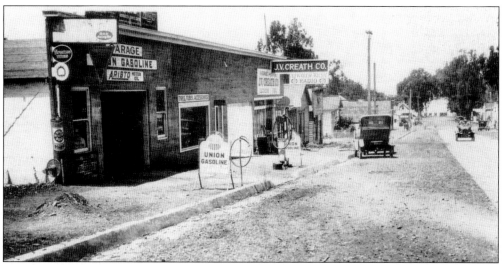

These 1925 photographs show Fifth Street (now Morro Bay Boulevard) looking west. J. C. Stocking's Garage sold "tires, tubes, accessories" and Union gasoline. Next door, J. W. Creath Company sold home furnishings, including Atwater radios. (Courtesy Juanita Tolle.)

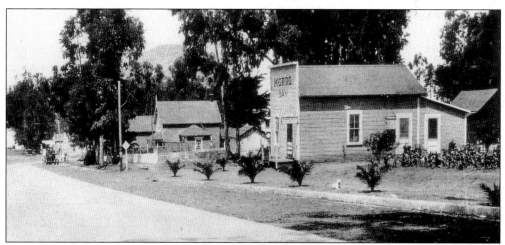

On the other side of the street, the building with the "Morro Bay" sign is an early post office. The structure to the left is the Schneider house. Note the width of the original road, which was designed to accommodate horses and wagons. The road today is about as wide as the paved portion pictured here. These postcards were created around 1925. (Courtesy Juanita Tolle.)

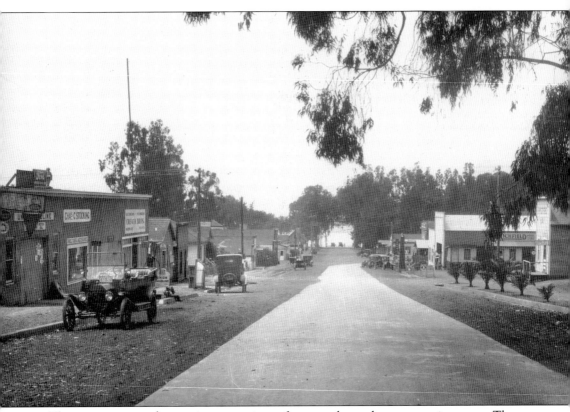

The same scene as the previous page, just a few years later, shows a growing town. The most obvious change is the theater (on the right with the false front) near the corner of Fifth and Monterey Streets. Named the Golden Hour Theatre by Noma Stocking, it served as movie house, theater, and dance hall. Across the street, son Charles Stocking had taken over the garage from his father, J. C., but the home-furnishing store sign had yet to be changed to "Creath Bros." (Courtesy Juanita Tolle.)

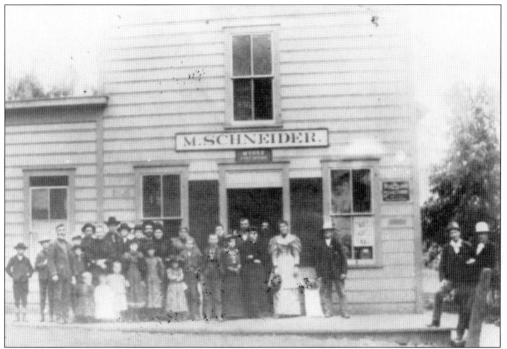

This much earlier picture, around 1895, shows the Mathias Schneider general store on the southeast corner of Fifth and Main Streets. According to historian Dorothy Gates, the Schneider family, (six sons and a daughter) came to Morro Bay around 1894 and soon built the store. (Courtesy Historical Society of Morro Bay.)

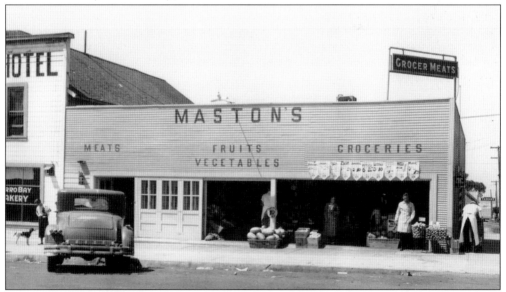

This is a well-known Glen Bickford photograph showing William Maston's second grocery store. It was located on the southeast corner of Main and Morro Bay Boulevard and survived as a grocery store under various owners until 1976. Their first store, across the street, had been leased from A. B. Spooner. Note the bakery sign in the hotel window. According to historian Vic Hanson, the bakery was run by the Johnson brothers. (Courtesy Juanita Tolle.)

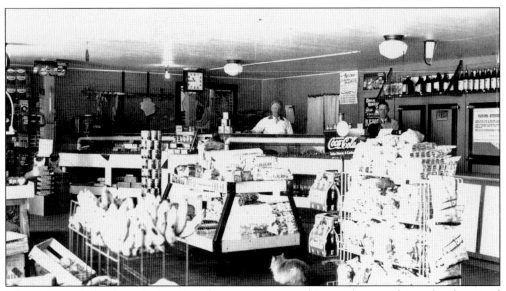

These photographs show the interior of Maston's store and its employees. This author has vivid memories of buying sodas and penny candy here. The ceiling of this building was lower than normal and the uneven wood floor creaked. The store had the unforgettable odors of oiled sawdust floor sweepings, an open butcher shop, and years of commerce. (Courtesy Wayne Bickford.)

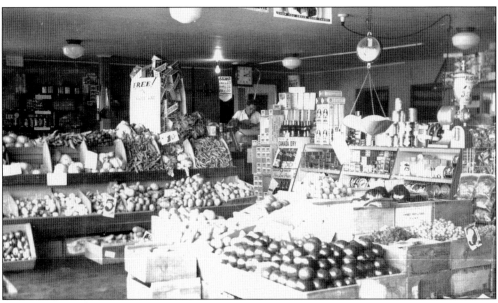

The small store always seemed to be overflowing with stock, as in this photograph. The Mastons owned much of the block and built and operated the hotel and a garage where the store was later constructed. (Courtesy Wayne Bickford.)

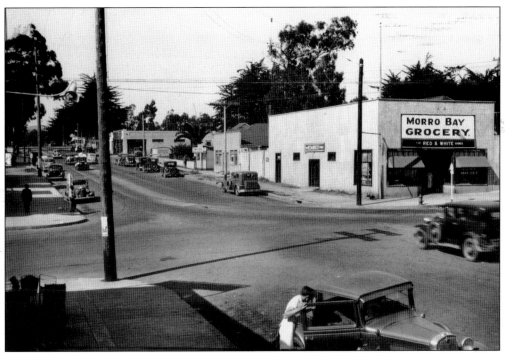

This is Morro Bay around 1930, looking north up Main Street. Maston's first store (see page 99) became Morro Bay Grocery. The young shopkeeper looking into the "tin lizzie" is in front of the new Maston's Grocery, out of the picture to the left. The large building left of center is Happy Jack's, the roughest bar in town. (Courtesy Juanita Tolle.)

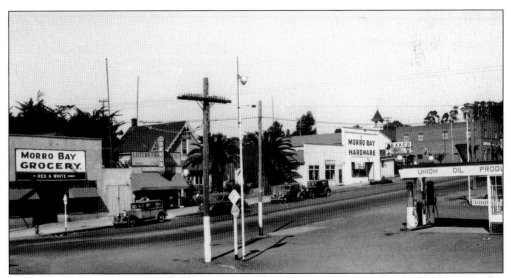

Looking northeast, up Morro Bay Boulevard, is Dave Leiter's drug store (next to the Morro Bay Grocery). Behind the drug store, with the gingerbread trim on the eves, is the old Schneider house. J. C. Tanner's Morro Bay Hardware occupied the old theater and dance hall (see page 104). The brick building, at top right, is the George Anderson's dry goods store and post office. (Courtesy Juanita Tolle.)

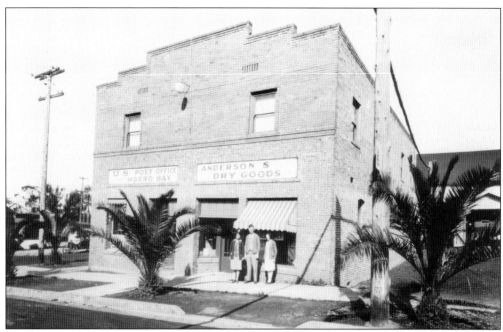

The first story of this brick building, at the corner of fifth and Morro Streets, was built around 1927 by George and Lillie (Brown) Anderson. Lillie had been appointed postmaster in 1918. Her new husband opened a dry goods store in one half of the building and she moved the post office into the other half. The following year they added the second story. (Courtesy Rosemary and Kay Thorn.)

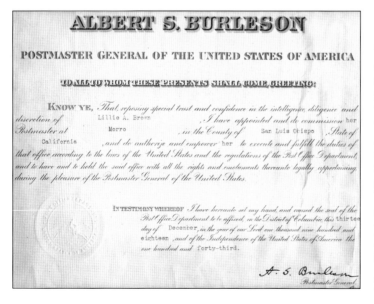

This is a reproduction of Lillie's first postal appointment certificate from 1918. She served until at least 1923, under the name Lillie A. Medieros. She also operated Morro Bay's first telephone exchange and a small library in the brick building. It housed several stores over the years; most memorably Bill and Harriet Payne's five-and-dime store. (Courtesy Rosemary and Kay Thorn.)

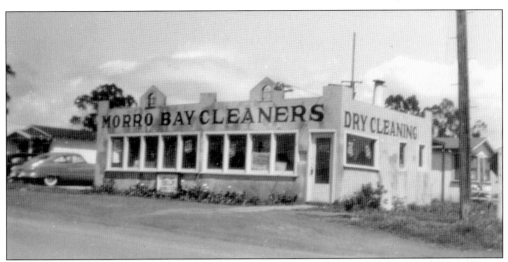

While visiting Morro Bay after his discharge from the marine corps in 1946, Coy and Inez House found this dry-cleaning business for sale. They purchased it on the spot, but soon found that there were no houses for rent in town. They had some furniture, so they set up housekeeping and sleeping arrangements in the new business. For three weeks they slept on the floor at night and rearranged each morning for business. Coy became a familiar sight, pressing shirts in the window, with clouds of steam venting out front. Coy and Inez operated the Morro Bay Cleaners for 41 years. (Courtesy Inez House.)

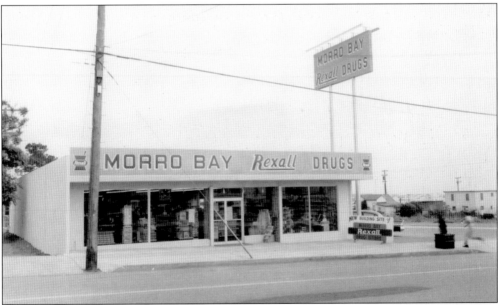

Harry Leiter opened the first drugstore in Morro Bay in 1928 (see page 105). His brother Dave joined him in 1929 and eventually took over the store from Harry. The little store on Fifth Street sold newspapers, veterinary supplies, cosmetics, liquor, and tobacco besides being the only pharmacy in town. Dave and his wife saw everyone in town almost every day and soon became a fixture in Morro Bay society. They operated the store until Joe and Kathryn Limon bought it in 1953. The Limons built this new Rexall Drugstore just two blocks down the street in 1963. They operated the business for 42 years. (Courtesy Kathryn Limon.)

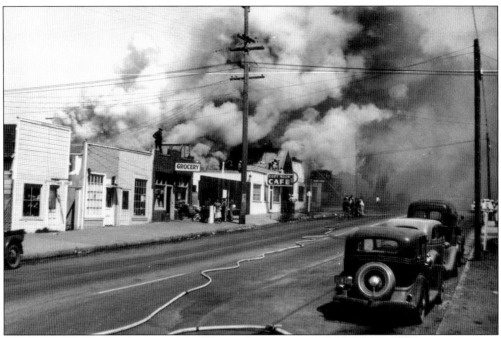

The Pool Hall fire of 1942 leveled that structure (see page 91). The first building not obscured by smoke is the Cozy Nook Café a popular daytime meeting place. The grocery store was run by Frank Cardoza. The next building appears to be divided in half, which was actually true. The couple who worked and lived there decided to separate, so they built a partition down the center of the building and each took half. The buildings served many purposes over the years. The south half, with the divided window, was Marie McKinnon's library in the early 1950s. (Courtesy Wayne Bickford.)

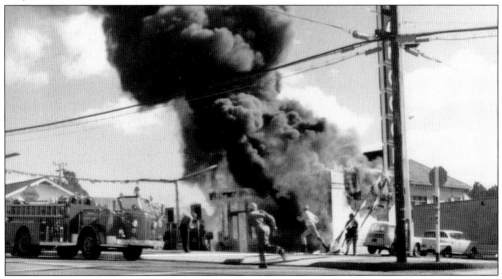

This is the dramatic 1970s Texaco service station fire at Fifth and D Streets (Morro Bay Boulevard and Napa). It was originally a Seaside station, built in 1941 by Ed Caccia. The building seen behind the fire was Ed's turn-of-the-century home. He also constructed the house seen over the fire truck in 1918 as a home for his aging parents (see page 121). (Courtesy Morro Bay Fire Department.)

Nine
WHERE PEOPLE LIVED

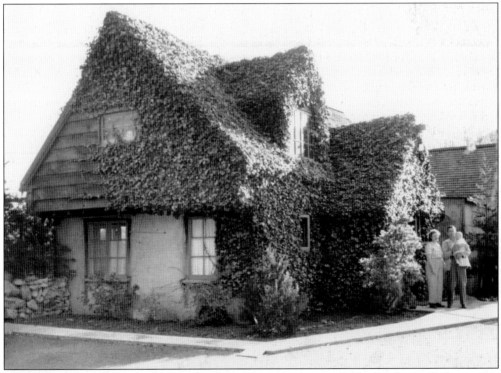

One of the most industrious of Morro Bay's British expatriates was Miles Castle. At the beginning of the Depression, he purchased two and a half acres north of town for $400. There he created his beloved Tudor cottage in the style of an English farmhouse, using adobe clay mixed with straw and natural tar. The one-foot-thick walls were formed up about 18 inches and the wet mixture was tamped in and allowed to dry. The forms were then raised and the process was repeated. Miles built the home during this country's most difficult economic time and obtained most of the materials through barter and trade. This 1945 image shows Miles, his wife Jean, and one of the authors of this book, Roger. (Courtesy Roger Castle.)

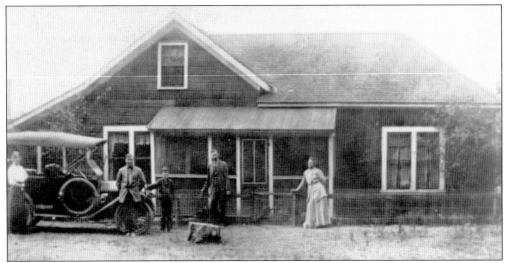

The J. N. McKennon home was built before 1900 on Main Street south of Fifth. Historian Dorothy Gates identifies J. N. and his wife (right), and their sons Hollis and Willis. The lady on the far left is identified only as a schoolteacher. Hollis later married Marie Walsh, who was a schoolteacher herself and later Morro Bay's librarian. (Courtesy Historical Society of Morro Bay.)

Joseph C. Stocking came to Morro Bay around 1896. The 165-acre Stocking ranch was located south of town, partially on land that is now the State Park and the Golden Tee Resort. He raised six children in this house. In this undated photograph, Margaret "Peggy" Stocking Parvin, the second youngest, stands on the porch of her home of more than 50 years. Her mother died when Peggy was 12, but she stayed on with her father, leaving for only a few years after she married. Her husband, Arthur Parvin, was a state park ranger. In the early 1980s, the remaining siblings sold the property to Golden Tee Properties, who developed condominiums on the land. The house was razed in 1983 as a fire department exercise. (Courtesy Historical Society of Morro Bay.)

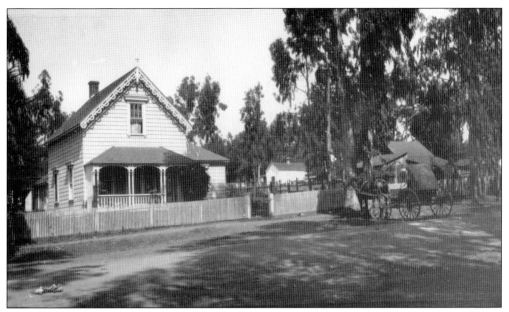

The old Schneider house on Fifth Street was actually built by the Spooner family in 1872 as Franklin Riley was laying out the town. David Spooner raised his family there while building and operating his grocery store at the northeast corner of Fifth and Main. Mathias Schneider came to Morro Bay in the late 1880s. He and his sons built another store on the southeast corner. They also constructed the first water system, with an elevated tank and a horse-powered pump, which supplied the neighborhood. (Courtesy Juanita Tolle.)

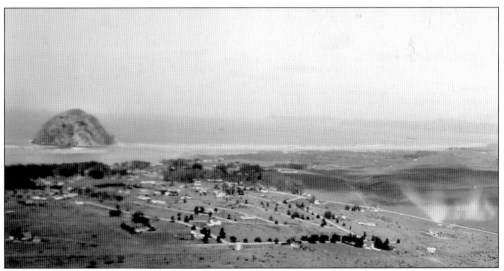

Here is a c. 1936 view of the heights from Black Hill. The road in the foreground is what would become Kings or Tulare Avenue, which went south toward the back bay over the future back nine holes of the golf course. Another road and tiny parking spot made this a popular vista throughout the 1950s and 1960s. It spot is still accessible, but the view is obscured by pine trees. (Courtesy Wayne Bickford.)

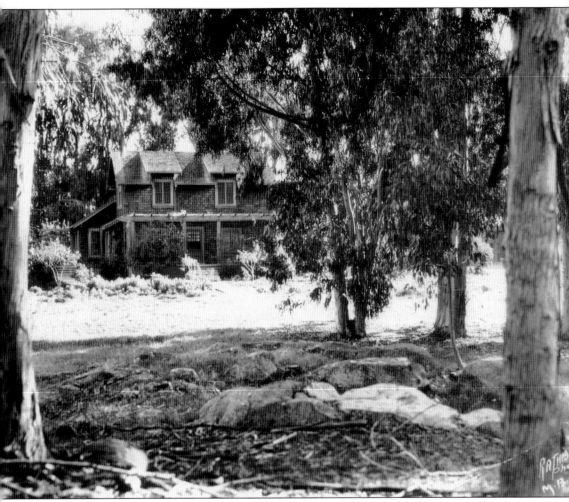

Robert Fairbank and Clair Fairbank-Ranney bought much of the land between what became the golf course and the bay from the Schneider family. They built this home in the early 1900s. Clair was instrumental in the development of the golf course and the Cabrillo County Club (see Chapter 10). In the early 1950s, a consortium of Morro Bay developers purchased four and a half acres in front of the house and built the Golden Tee Resort, now the Inn at Morro Bay. The tall trees on the remaining property were a nesting site for Great Blue Herons. The area eventually became a state Heron reserve and the house was demolished in the mid-1970s to protect the rookery from fire. (Courtesy Juanita Tolle.)

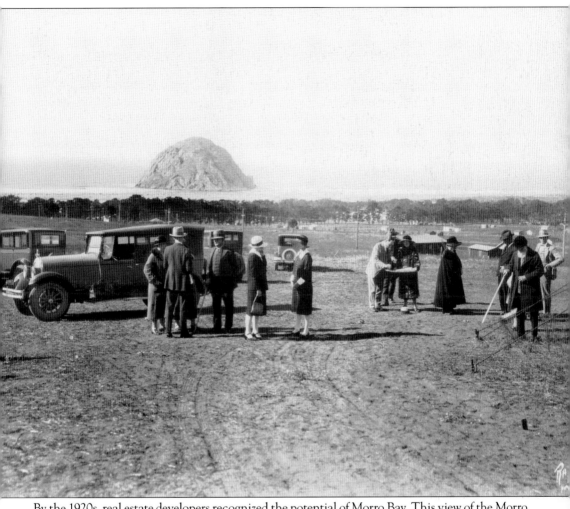

By the 1920s, real estate developers recognized the potential of Morro Bay. This view of the Morro Vista development, later known as "the heights," shows real estate salesmen entertaining their prospective buyers. They are standing approximately where Fairview Avenue is today. (Courtesy Juanita Tolle.)

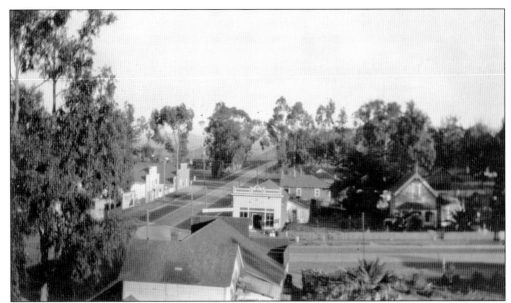

This is the corner of Morro Bay Boulevard and Main Street, looking north. Notes on this 1920s postcard, attributed to Elizabeth Roy, identify the building in the center as Maston's Grocery. The house to the right is the old Schneider house (see page 111). The last building on the right is Young's Hall and warehouse, converted to a dance hall. North of that, in the trees, is a stable and a corral. (Courtesy Juanita Tolle.)

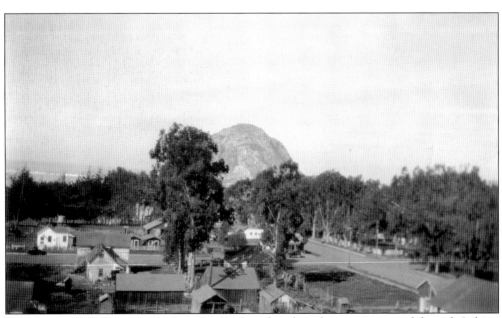

This photograph looks west with Morro Bay Boulevard on the right, running toward the rock. Judging by the growth of the trees, it was taken in the 1930s or even 1940s. (Courtesy Juanita Tolle.)

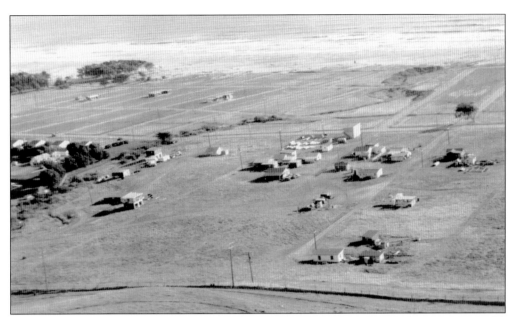

Development of the north end of town began in the 1920s when E. G. Lewis purchased the beachfront property from Morro Creek north. Lewis, a nationally known developer, wanted additional enticement for his Atascadero Colony that was inland. He built a fine Spanish styled hotel, the Cloisters Inn (page 118) and one model home. Although sales of lots were brisk, these were the only structures built during his time. Legal title complications and the Depression restricted growth until the 1950s. This photograph was taken around 1955. The present-day Kodiak Street is at the center and the two-lane Highway 1 crosses the upper third. (Courtesy Roy Kline.)

The Neil Klein family was typical of the residents of the area. Neil served in the army air force during World War II and brought his new wife to Morro Bay because he had relatives there and he loved the sea. A jack-of-all-trades, he made a good living helping his uncle build business and homes in town as well as being a boat captain. In 1951, they bought this lot, on what is now Kodiak Street, north of town for $125. Over the next 30 years they built their own home and raised four children. (Courtesy Roy Kline.)

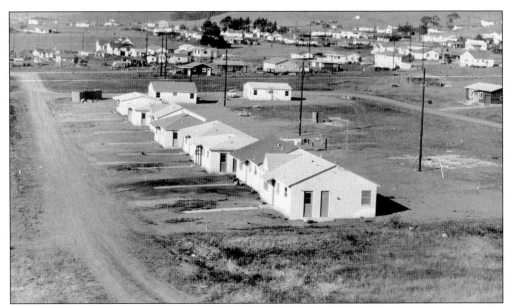

By the end of World War II, legal title to the lots of north Morro Bay had been resolved. The economic boom that followed spurred development in the area. This mini-development, created by Jesse Drake, later a county supervisor, was typical. Some of these homes on Seaview Street still exist. (Courtesy Wayne Bickford.)

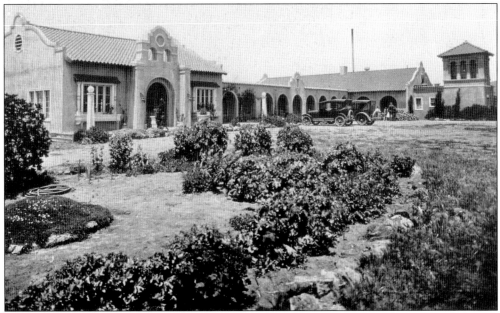

The Cloisters, also known as the Morro Beach Inn, was built by E. G. Lewis in 1925. Located at the beach end of what is now San Jacinto Street, the inn was to be the centerpiece of the Atascadero Beach development. He hoped that the availability of beach-front property, only ten miles west of Atascadero Colony, would boost sales. An auction in 1927 drew 250 people, who bought lots at $200 to $300 apiece. The hotel was the finest in Morro Bay for more than a decade. It had accommodations for about 40 guests and additional beach cottages nearby. (Courtesy San Luis Obispo County Historical Society.)

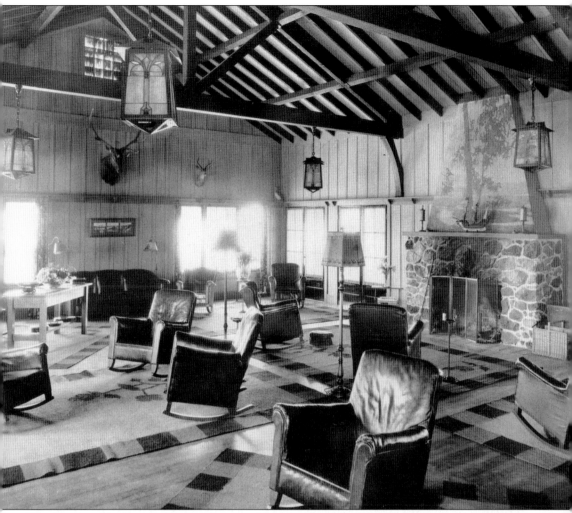

The Cloisters Inn day room featured views of the beach and Morro Rock. The resort offered fine dining and, according to historian Vic Hansen, "a galaxy of the finest entertainment" nightly. The inn remained open at least through 1941, and was managed at that time by Chick and Mildred Greenelsh. (Courtesy San Luis Obispo County Historical Society.)

The inn was the epitome of luxury in Morro Bay in the 1930s, as this view of the dining room shows. However, E. G. Lewis's dream of a seaside resort was lost due to the Depression and other economic issues. Much of the Atascadero Beach property, including the inn, eventually came under the control of the county. During World War II, following the sinking of the *Montebello* (see page 96), the Cloisters housed a regiment of soldiers assigned to defend the beach. At the end of the war, the property was abandoned, soon vandalized, and eventually destroyed by a fire. Salvaged building materials found their way into many local homes. (Courtesy San Luis Obispo County Historical Society.)

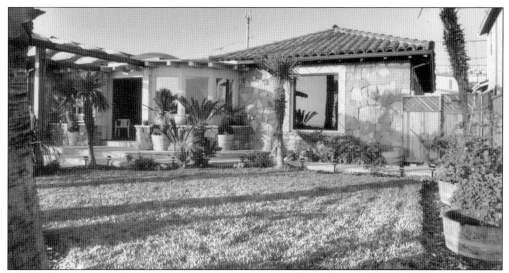

This home in north Morro Bay is a tribute to one man's skill and perseverance. Art Criddle designed and built the house using rubble from Morro Rock. Art was working on the construction of the breakwater in 1943 and over three years he collected about 500 tons of rock, taking home about 1,000 pounds a day in his Model T truck. He split and shaped each rock by hand. The family moved into the "big house" on Thanksgiving Day 1947. Art and Doris sold the home in 1973 and for few years it served as a fine restaurant known as the Criddle House. It is currently once again a private home. (Courtesy Thom Ream.)

This is Morro Union Elementary School, built in 1935. The first recorded elementary school was in the Grange building at 2nd and C Streets (now Marina and Monterey). It was used from 1882 to 1919. Morro Bay's next school was constructed on Main Street at the corner of what is now Beach Street (see page 92). The Spanish-style building housed four high-ceiling classrooms that were used until this school was built. This structure provided classes K–8 until the high school was built in 1959 and absorbed the eighth grade. A growing population necessitated the building of a second elementary school, Del Mar School, north of town, in 1962. A reverse of that trend finally closed Morro Elementary in 1992. (Courtesy Thom Ream.)

Ettore (Ed) Caccia was the son of a Morro Bay dairy farmer. According to Dan Reddell, "In 1918, Ed decided to build a new house for his elderly parents, next door to [his] home. . . . He hired Ted Maino, who constructed the first buildings at Cal Poly, to build it. At a cost of $5,000, the new home featured a concrete foundation, cement siding, asbestos roof tile, a stylish porch, and large yards. Construction was completed in 1919." After several remodels and housing three generations of Caccias, the home, pictured here, is currently Dan Reddell's Bayshore Realty office. (Courtesy Thom Ream.)

This is Ed Caccia's original home at 560 Fifth Street, now Morro Bay Boulevard. According to Dan Reddell, Ed bought the entire block with this house on it from Alva Paul in 1917 for $2,500. In 1941, Ed moved the house about 100 feet back from Fifth Street and built Seaside service station. This is said to be the first home in Morro Bay to be wired for electricity. (Courtesy Thom Ream.)

Ten

THE THINGS PEOPLE DID

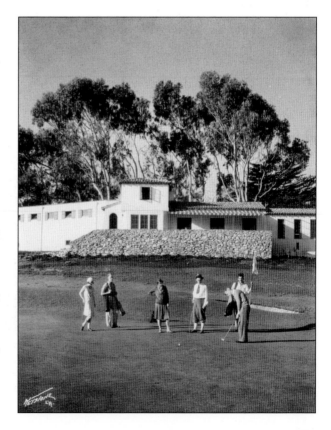

Morro Bay has always been tourism, vacations, and good times in general. Like all towns in America, people love the special events. Even in the worst of times, people knew how to have fun. By the end of 1928, Edward Murphy and Clinton Miller had created a nine-hole golf course and the elegant Cabrillo Country Clubhouse as a selling point for their Morro Vista properties. One of the major minds and energies behind the golf course was William "Bill" Roy. He was Miller and Murphy's 'right-hand-man at Morro Vista and had worked for T. J. Lawrence before them. He was instrumental in the planning, construction, and management of the course and the clubhouse. In this picture, Bill is putting on the ninth hole, the caddies are Sidney Nichols (behind Bill) and Basil Jackson, and the other members of the group are unidentified. (Courtesy Juanita Tolle.)

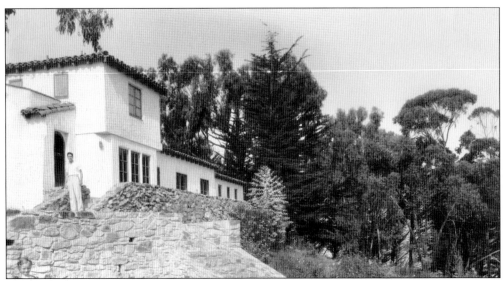

The clubhouse was built on the shorefront of White's Point. According to an account by Clyde Jones, this wall was built by George Seih (who was nearly blind) over a period of several weeks. The lower portion of the wall still stands as a retaining wall for the natural history museum parking lot. The two drain holes below the unidentified man can still be found in the wall today. (Courtesy Historical Society of Morro Bay.)

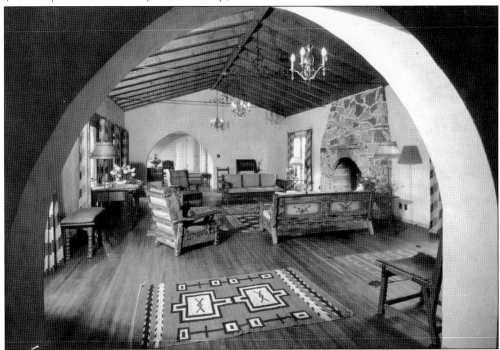

This building echoed California's mission architecture, and the rustic elegance of the interior emulated that of the Cloisters Inn on the other side of town (see pages 117 and 118). The building served as clubhouse for the country club and public meeting hall during the hard times of the Depression. This room was known as the Great Hall, seen through the archway from the dining room. (Courtesy Juanita Tolle.)

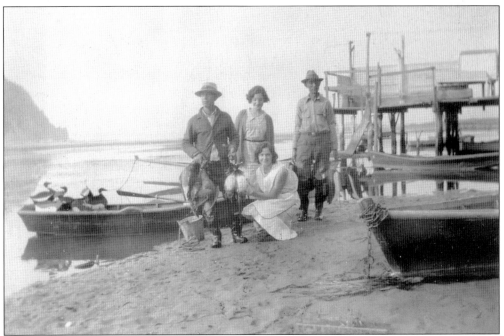

Hunting and fishing have always been a means of sustenance and sport in Morro Bay. The wide, quiet expanse of the back bay is ideal for water fowl. Corneluis Sylva and his son Al were among the first to capitalize on this source, offering duck-hunting excursions. Pictured here are Corneluis (left), with his friends, the Lamb family, with a day's take. Note the duck decoys in the stern of the boat, which were handmade by Al. (Courtesy Adele Sylva Costa.)

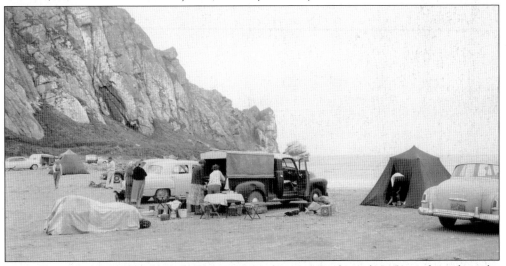

Morro Bay was clearly a beach-camping destination for many. In the early 1950s, judging from the cars, folks camped all along the beach, including what is now Coleman Park and the parking lot at the base of the Rock. In 1934, the state acquired the golf course and all the land surrounding it, as well as the back bay and its shore and sand spit. This would eventually become Morro Bay State Park. In the late 1970s, a small campground was built at the extreme north end of town. Today camping is only allowed in designated campgrounds. (Courtesy San Luis Obispo County Historical Society.)

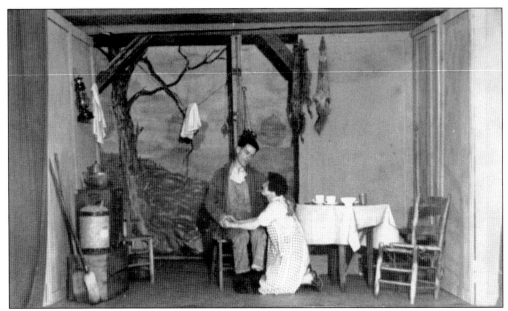

Arts and crafts of all kinds have always flourished in Morro Bay. The beauty of the area attracts and inspires artists, musicians, writers and all creative disciplines. Nothing combines the arts like a live production, and residents have always entertained themselves with plays, musicals and even an occasional opera. Here, in the early 1930s, a young Neil Moses and Olive Cotter perform in the Gold Hour Theatre (see page 102). (Courtesy Juanita Tolle.)

A late-1950s production of *Claudia* brought together a diverse group of citizens. The young man on the right, Dick Weis, was a short-time resident with his eye on Hollywood. Jean Castle, Morro Bay's assistant librarian, played his mother-in-law. Bob Pyle, a local art gallery owner, played the part of her husband. The young lady on the left is unidentified. The production was staged at Morro Elementary School (see page 119). (Courtesy Nancy Castle.)

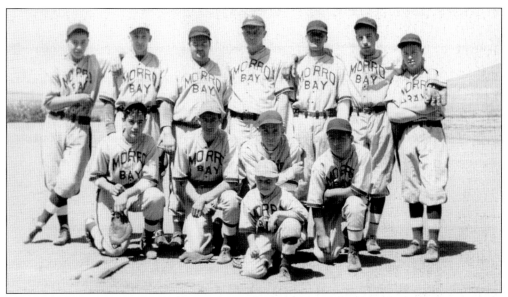

This is the 1940 Morro Bay city league team. The league was a loose association of teams from other county towns like Cayucos, Cambria, San Miguel, and Paso Robles. The group was funded by donations, and the Sunday afternoon games were well attended. Pictured here from left to right, are (kneeling) John Brebes, unidentified, Ed Revia, and Red Hottray; (back row) Sonny Pierce, Skeet Kerwin, unidentified, unidentified, Frank Brebes, Jim Emmons, and Ray Wagner; and the boy in front is unidentified. (Courtesy Wayne Bickford.)

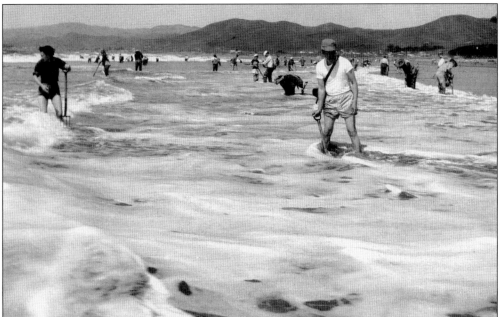

A popular activity that has all but vanished from the beaches is clamming. In the early part of the century, the Pismo Clam was so abundant that, according to historian Lynne Landwehr, riding a buggy "along the sand at low tide felt very much like riding on a cobblestone street." Commercial clamming was prohibited in 1947 and by the late 1950s the sport limit was 10 clams per day, with the shell being a minimum of five inches at the widest point. (Courtesy Wayne Bickford.)

As the pictures presented in this volume attest, Morro Bay is a very scenic and photogenic corner of the world. It is no surprise then that artists have been drawn to the area. By the early 1930s, Morro Bay was home to several noted professional artists. Pictured here in Carmel is Harold Knott. Others include Charles H. "Robby" Robinson and Aaron Kilpatrick. Other California artists who spent time painting in the area include Ejnar Hanson, Peter Nielsen, William Wendt, and William Ritschel. (Courtesy of Harleigh Knott.)

Harold Knott, shown here with his portable paint box and folding stool, moved to Morro Bay in 1928 with his bride, Rachel. They bought a New England–style house on Ridgway Avenue, one of the first homes in the Morro Heights area. Harold had done various kinds of design work before coming to Morro Bay, where his main focus was on painting. His works were shown at such prestigious venues as the Stanford Art Gallery in Palo Alto and the Paul Elder Gallery in San Francisco. Museums with his works in their permanent collections are the Monterey Art Museum, the Laguna Art Museum, and the Chaffey Museum. (Courtesy of Harleigh Knott.)

BIBLIOGRAPHY

Gates, Dorothy, and Jane Bailey. *Morro Bay's Yesterdays*. Morro Bay, CA: El Morro Publications, 1982.

Moses, Mary J. *Morro Bay Remembered*. San Luis Obispo, CA: Blue Oak Press, 2001.

———. *Morro Bay Remembered, Volume II*. Paso Robles, CA: Premier Press, 2003.

http://www.oldmorrobay.com

http://www.bayshorerealty.net

http://www.historyinslocounty.com

Across America, People are Discovering Something Wonderful. Their Heritage.

Arcadia Publishing is the leading local history publisher in the United States. With more than 3,000 titles in print and hundreds of new titles released every year, Arcadia has extensive specialized experience chronicling the history of communities and celebrating America's hidden stories, bringing to life the people, places, and events from the past. To discover the history of other communities across the nation, please visit:

www.arcadiapublishing.com

Customized search tools allow you to find regional history books about the town where you grew up, the cities where your friends and family live, the town where your parents met, or even that retirement spot you've been dreaming about.